THE PAINTINGS OF
Leslie Worth

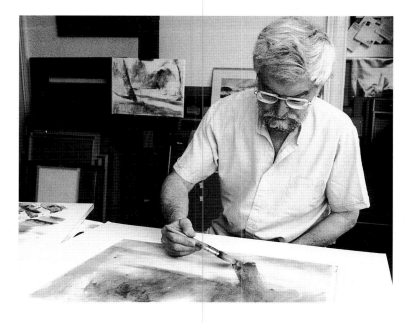

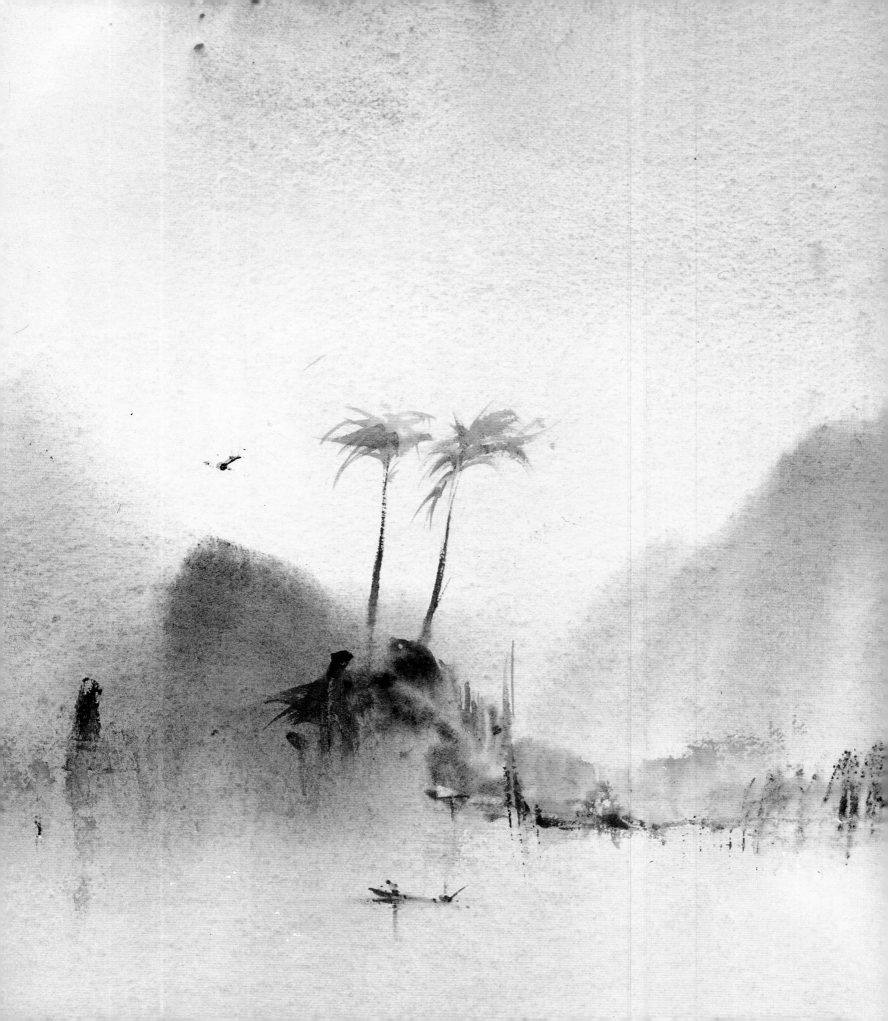

THE PAINTINGS OF
Leslie Worth

MICHAEL SPENDER

David & Charles

FOR GABRIEL

ACKNOWLEDGEMENTS

The artist and author are grateful to the owners of the paintings in this book for making them
available for photography and inclusion. We are also indebted to Dudley Dodd of the National Trust Foundation for Art,
and other staff of the Trust, for their encouragement and help with the section on the fire and restoration at Uppark.
We should like to thank the BBC for permission to use extracts from the Radio 3 programme 'Third Ear',
Leslie Worth talking to Michael Spender, produced by Judith Bumpus. Thanks also to the Royal Watercolour Society for
permission to quote from its video 'The 300th Exhibition', and to Chatto and Windus for permission to quote from
Steve Ellis's translation of Dante's *Hell*, first published in 1994.
All the photographers and photographic libraries deserve our thanks, particularly Joss Reiver Bany, who
undertook the lion's share of the work, as well as Thos. Agnew & Son, Bankside Gallery, A.C.Cooper Ltd.,
Prudence Cuming Associates, Michael Giles, Sam Lambert, National Trust, Sydney W. Newbery,
Royal Academy of Arts/Photo Studios Ltd., and Rodney Todd-White & Son.
Agnew's has been the artist's dealer for more than four decades, notably through its former chairman, Evelyn Joll,
and he and the other gallery staff are to be thanked for their constant support and interest.
Thanks also go to Judy Dixey and the staff of the Bankside Gallery who organised the retrospective exhibition which was
planned to coincide with the publication of this volume. Alison Elks and her colleagues at David & Charles have been
equally supportive during the writing and production of the book.
Finally, and traditionally, we would like to record the patience and good humour of Helen Spender and Jane Taylor,
for supporting us in this pleasant task. And as the writer, I get the last word — one of appreciation of a genuinely
gifted and articulate painter.
Michael Spender, Hampshire 1995

Preceding pages: Page 1, left: Leslie Worth working with a large watercolour brush (1994) Photograph by Joss Reiver Bany
Page 1, right: Leslie Worth looking against the light at the painting surface (1994) Photograph by Joss Reiver Bany
Page 2: **River Li, Guilin, with two Bamboo Canes** *(1994) (Detail. See page 85) Watercolour, private collection*

A DAVID & CHARLES BOOK

Copyright © Illustrations: Leslie Worth 1995
© Text: Michael Spender 1995
First published 1995

Michael Spender has asserted his right to be identified as author of this work in accordance with the
Copyright, Designs and Patents Act 1988.

A catalogue record for this book is available from the British Library.

ISBN 0 7153 0189 6

Design and Typesetting by Malcolm Couch
and printed in Singapore by C.S. Graphics Pte Ltd
for David & Charles
Brunel House, Newton Abbot, Devon

CONTENTS

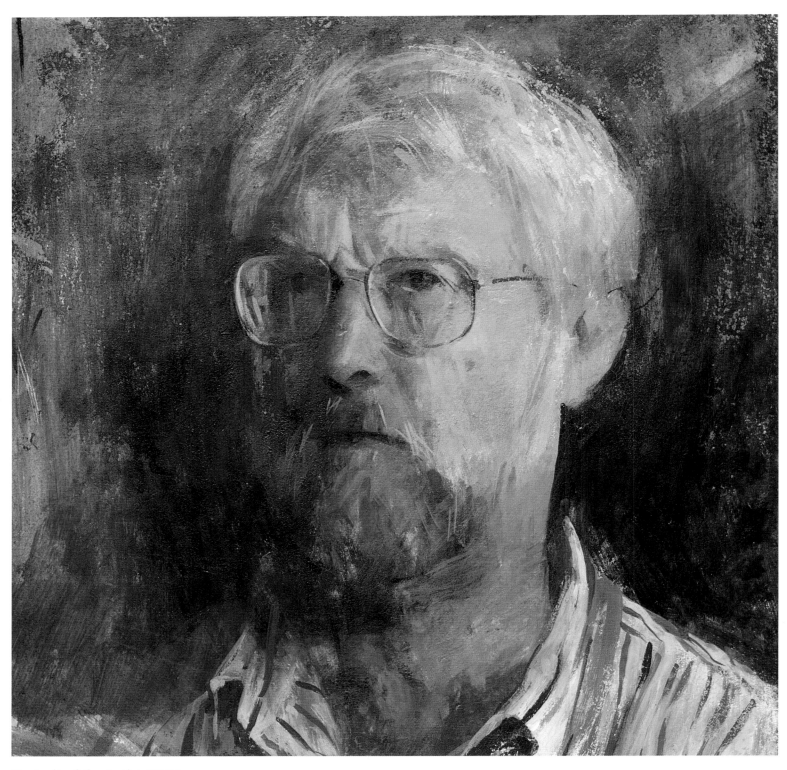

Portrait of the Artist (1991)
Watercolour and mixed mediums,
9 ¹/₂ x 9 ¹/₂ in (24 x 24cm) private collection

FOREWORD

We British are very curious in our prejudices, especially when it comes to matters of art. Watercolour is a case in point. It is a medium in which, so we like to pride ourselves, we display a peculiar natural talent, and indeed we count the work in watercolour of many of our artists of the past, those at least who have habitually, if not exclusively, employed it – Turner, Bonington, Rowlandson, Lewis, Cox, Palmer, Varley, Lear and so many more – as among the greatest and most characteristic of our national achievements.

And yet we still don't seem to count it as highly as all that. In the hierarchy of practice, the expectation, almost amounting to a requirement, is that the work on paper, the watercolour even of the most exquisite accomplishment, is bound to be so much cheaper than the oil on canvas, which is to say proper painting. 'Oh, so you're a painter, are you?', runs the conversation familiar to all artists. 'Tell me, do you work in oils, or only in watercolours?' Are you, that is to say, a grown-up and thorough-going professional, or, the fiendish difficulty of the medium of watercolour notwithstanding, a mere dabbling amateur?

Indeed the technical difficulty serves if anything to compound the prejudice by adding another, which is that technical display is vulgar, superficial, unworthy, in the end somehow un-British. It is a wonderful and typically British double-bind. The defence that no one can work properly and adventurously in watercolour without such technical display is held, of course, to be no defence at all.

Leslie Worth gives the lie to all this, to anyone at least with eyes open enough to see. His technical command is manifest, astonishing as much in its breadth and scope as in its subtlety and finesse, yet it never gets above itself, is never out of place. Always it serves the integrity of the work, that mysterious balance to be achieved between the external reference and interest, and the qualities of the work itself as a surface and object in its own right. The true artist will always defer to this mystery, discreetly and unselfconsciously, and Leslie Worth is discreet and unselfconscious to a fault.

A foreword such as this is no place in which to make any particular critique of the work, which will follow in any case from other hands. It is enough to say that for all his personal modesty, Worth stands rightly within the great tradition of the topographical watercolour, at once romantic in its sensibility and objective in its address to its subject, as it has developed in this country over the past 250 years or so.

He will, it is true, win no Turner Prize for that, yet in its own quiet way, his work is as radical and adventurous as any in stretching and exploiting his chosen medium to the limit. I would only repeat what I wrote of his work once before, that I would have it just as it is, so deceptively modest in its radicalism and adventure, so honest in its response and true to itself. He is an artist who can make of a landscape, of cliffs and valleys, an image so vast in the mass and space that it describes as to take the breath away. And he can make the smallest study of a London street in a snowstorm that even so is nothing less than a *tour de force*. And I count it a privilege here to be allowed to say as much.

WILLIAM PACKER

1
THE EMERGING ARTIST

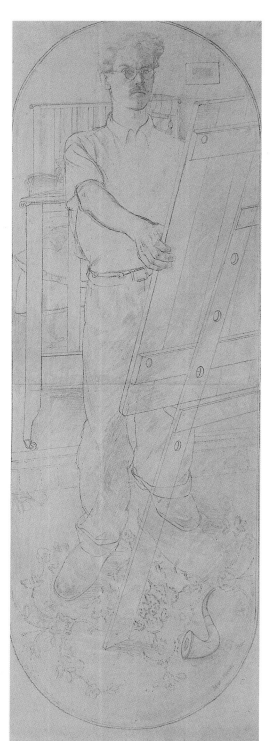

If Leslie Worth was not of an inquisitive, meditative and yet intellectually rigorous turn of mind, he would probably still be a good painter. But the level of perception, of mystery and yet of lucidity of expression that is to be found in his work singles him out from most of his contemporaries. These qualities have to be appreciated in the context of a facility with the watercolour brush that he seems to find faintly embarrassing, considering the perceived nightmarish behaviour of the medium.

If figurative painters have any curiosity at all about what makes things tick, they tend to turn this upon themselves from time to time. Worth is no exception. On the occasions he has studied himself, it has characteristically been in a mood of experiment. One example is the near life-size pencil-and-wash drawing, made when he was twenty-six, which is large by any standards. Three decades later he painted the oil self-portrait on the previous spread, and another decade further on, the watercolour overleaf. Worth is still the lean, rather wiry figure we see in the pencil drawing, a man more inclined to be abstemious, even ascetic, than indulgent.

The self-examination in the two head-only studies is unflinching, and the oil is an entirely convincing, speaking likeness. In both paintings he has painstakingly constructed the image, brush-stroke by brush-stroke, carefully examining and delineating every feature. The deliberate build-up of the watercolour demonstrates that Worth's fluency with the medium does not make him a splash-and-wash merchant. However fluid and accidental Worth's most glorious watercolour washes might be, or might seem, they are applied for a reason, with the consideration and thought that are typical of the man.

This book is not a chronological survey of Leslie Worth's career: that is an altogether larger task than is being attempted here. Rather it is an appreciation of his work and an attempt to understand and interpret it in terms of certain major and minor themes and concerns that have shaped his *œuvre*. On occasion, paintings will appear in unexpected places to make comparisons across these themes. Thus we will come across grazing sheep among the mural schemes and burning oil wells in the midst of a disastrous fire at a National Trust property in Sussex. This first chapter, however, sets the scene by looking at some of the artist's early work.

Leslie Worth was born in Bideford, North Devon, in 1923. His father was a petty officer in the Royal Navy, his paternal grandfather a country carpenter, and his family was rooted in traditional crafts. In this background and his upbringing close to some of England's finest coastal scenery lie the seeds of much of the subject matter of his later work, and even his technical prowess as a painter. He now recognises the quality of the bright Devon light as a formative influence on his later work; and the profoundly understood and beautifully drawn boats we shall see have their origins in exceptional schoolboy drawings of his father's ship, HMS *Resolution*; and the glorious freedom of technique and expression in his watercolours is the prerogative of a meticulous craftsman who from childhood has valued and enjoyed working with his hands.

When Leslie was five the Worth family moved to St Budeaux, near Plymouth, where his father was stationed at the naval base. He cannot remember a time when he was not drawing, and as a young boy he was called upon to make surprisingly mature drawings of animals, as a party trick. One anecdote of his time at a local Church of England elementary school tells of a reluctant teacher finally allowing the pestering boy to do a drawing, and then being so overwhelmed with the quality of the result that she rushed off to show it to the head teacher.

From school he went straight to Plymouth's art school at the age of fifteen. He failed his Army medical in 1941, joined the Air Raid Precautions service and undertook various civil defence

duties, while remaining an art student. The wartime bombing of Plymouth drove the family back to Bideford and he attended the art school there. In September 1943 he won a prized place at the Royal College of Art.

To escape the Blitz the Royal College had been evacuated from its Kensington premises to Ambleside in the Lake District. There, under the guidance of Gilbert Spencer, brother of the even more well-known Stanley Spencer, the students of the College's Painting School received a traditional, some would say overbearing, academic education, centred on objective study and drawing. Worth has described the experience as a provincial existence under a narrow, inflexible regime. But it was by no means an entirely negative period for the emerging artist:

> The Royal College of Art was marvellous in many ways. It was certainly very good for me, coming from little 'one horse' art schools, where there was very little competition, and getting into a bigger field, and I think also the rigours of the academic training gave one a great sense of security, from which one could move on. Matisse said that the only important art education was an academic education, and he knew exactly what he meant by that, and I'm inclined to think so now. It gave one a facility, if you like, in which one could ignore one's technical skills. I didn't have to worry about drawing things: you know; one drew naturally.
>
> One didn't have to worry about tonality because one had already mastered it; and one understood a lot about the structure of painting. I think, in a way, that the rather rigorous training, and drawing and objective painting, gave one an ability to deal with landscape, which is a much more transient thing. And it made one aware of structure and all one might imply by that. And I think the discipline of having to spend long hours in pursuit of something which was fairly intangible gave one great staying power.

So the Royal College provided the foundations upon which he could build a career as a painter, chasing some of the more subtle effects of the natural world. With the disciplines learnt under Spencer he would later be able to apply his innate craftsmanship and his developing draughtsmanship to the more extreme flights of fantasy possible with a watercolour brush. As we leaf through the pages that follow we shall discover that Worth has never been timid in the application of his chosen medium. But it should also be apparent that a strong understanding of the significance of drawing, of the mark made by the artist, informs every brush-stroke, every wash.

But why the fashionably underrated medium of watercolour? We shall see that the respectable medium of oil painting was predominant during Worth's growing years as an artist. Before we attempt to answer the question, we look at one of the earliest surviving oils, and a drawing, from his time at Ambleside.

The influence of the work of the Spencers, particularly Stanley, on young artists of Worth's generation, was profound. A small oil painting by Worth entitled *The Sluggard* (page 11) and a drawing of *A Village Funeral* (page 12) indicate that Worth was not impervious to this influence. The subject and rather heavy style of the large drawing are redolent of Stanley Spencer. In the oil the colouring, the perspective, the surreal image of the necks of the screeching swans poking up from their crates, and the farm-worker who has had a nap in the straw which one of his horses has started to munch are all traits reminiscent of the brothers' work. The element of humour, which on occasions we will see developed and personalised in his post-College work, would have come naturally to Worth. His wry sense of the absurd is well known amongst his fellow painters. He is a dignified man, as befits someone elected to the Presidency of the Royal Watercolour Society in 1992. But when they appointed him to the position, his colleagues in the RWS must also have been looking forward to the outlandish and frequently self-deprecating stories of after-dinner speeches to come, made in his soft Devonian burr.

Worth had been elected to the Society in 1958. He has since 1951 been a member of the Royal

Opposite:
Portrait of the Artist (1949)
Pencil, 58 1/2 x 19 3/4 in (148.5 x 50.2cm)
private collection

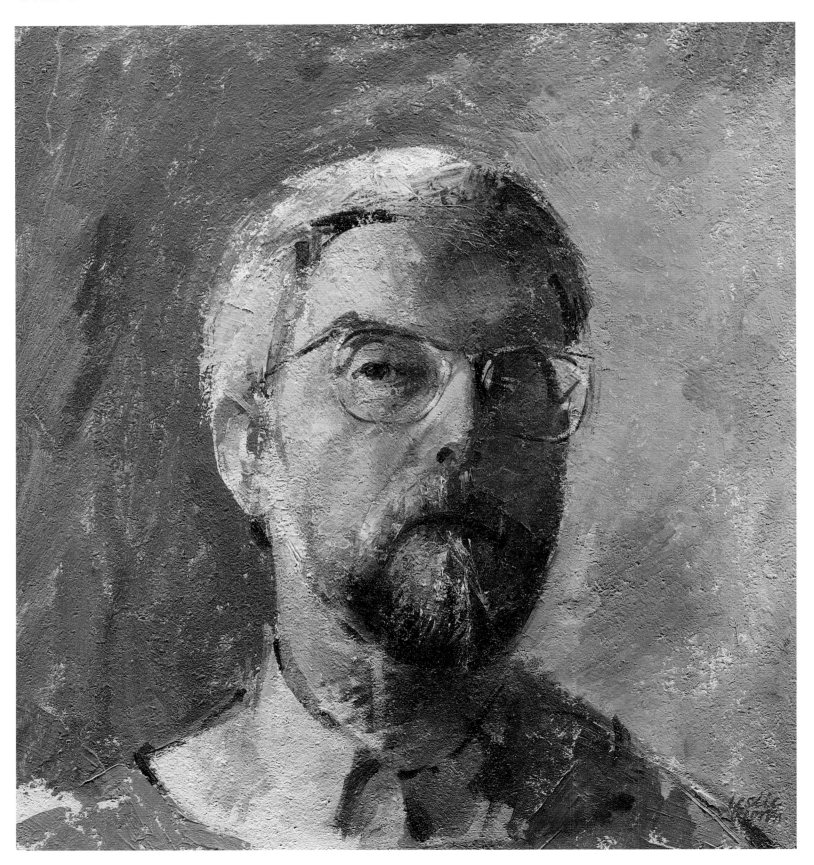

Society of British Artists, latterly giving his services as Keeper. And for most of the 1950s he was a member of the New English Art Club. His greater commitment over the years, however, has been to the society that celebrates his chosen medium, the RWS. In 1983 he became Vice-President for Ernest Greenwood, continuing to serve with Greenwood's successors Maurice Sheppard and Charles Bartlett, and finally agreeing to stand for the presidency on Bartlett's retirement. So his identification with the medium of watercolour is considerable. But what process led him to becoming a painter in watercolour?

I would say I've always used watercolour, as a child and later on as an art student. I remember being at school with a boy who was much more ambitious than me. He painted in oil and I only painted in watercolour. Somehow I felt a sort of second-class citizen, compared to him. Watercolour became something which was natural, but during my period of study, and particularly at the Royal College of Art, one was essentially an oil painter, which I happen to think was an extremely good grounding for a watercolourist. I think the tonal control and things like that which oil allowed one, as against the really rather transient medium of watercolour, was the right way to do it, contrary to public expectations. Most people would profess to say it is the other way round, that

Opposite:
Portrait of the Artist (1980)
Oil on panel, 12¹/₈ x 11in (30.8 x 27.9cm)
private collection

The Sluggard (1944)
Oil on board, 8 ³/₄ x 12 ⁵/₈ in (22.2 x 32cm)
private collection

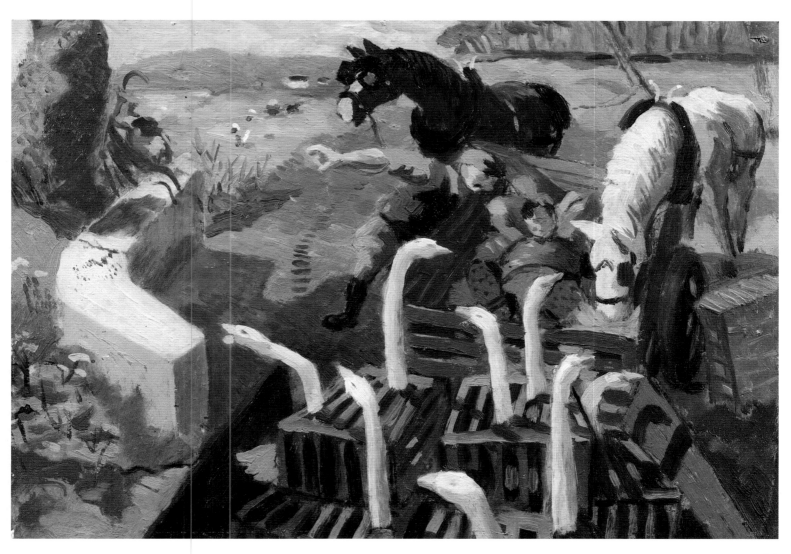

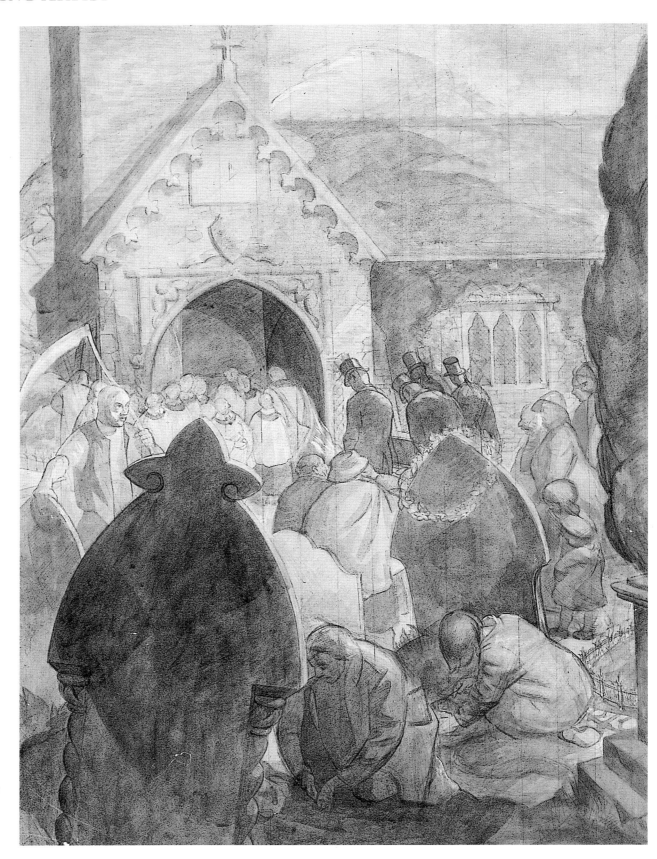

A Village Funeral
(c.1944)
Pen and wash, and
Chinese white bodycolour
over pencil, 23 x 17¹/₄ in
(58.4 x 43.8cm)
private collection

one should start in watercolour and then if you're any good you might graduate to oil. I would reverse the process I think.

Worth's watercolour *œuvre* has demonstrated, in its own way as persuasively as that of his great antecedents, Thomas Girtin, J.M.W. Turner, John Sell Cotman and David Cox, that, contrary to the perceived view, watercolour is as readily capable of expressing powerful visual ideas as any other medium. But Worth would always say that he is a painter, an artist first and foremost, not a watercolourist. No matter what the medium it is the concerns common to all artists – the understanding of form, colour and line, and the expression of self – that are his concerns.

Another question arises. Why, in the age of photography and film, and nearly nine decades after Picasso turned representational painting upside down, is an obviously serious artist like Worth concerned with painting his surroundings? And if it comes to that, do depictions of the landscape and the weather bear any relevance to the modern urban environment most of us in the West inhabit?

I don't really think it's irrelevant. Here one's trying to distinguish between a preconception, which may be irrelevant, and the actual practice. Was Paul Nash, for instance, irrelevant? He was a landscape artist. He drew his inspiration from the English landscape. There's nothing wrong with the subject matter. It's not the subject matter that can be either relevant or irrelevant. What might be is one's approach to it or one's perception of it.

A landscape is more of a conception than something which is a reality in itself. And by landscape I mean the whole visible and natural world which we inhabit. And landscape is as much to do with suburban streets and inner cities as it is to do with green fields. I think that as soon as people start to talk about landscape, they think of it somehow as divorced from human activity, that it exists as a sort of ideal world, which somehow or other has escaped contamination by human industry and so on. But the sun shines on us, the rain makes us wet, the wind blows us about. These are great natural forces which surround us and which we cannot escape from entirely, however much we choose to insulate ourselves, in tin boxes on wheels, or in brick houses.

No, I think my own painting is very much concerned with that. Of course, self-deception is the last deception one's going to jettison, but without deceiving myself I would have thought that I don't set out to present an ideal pastoral world. But the fact that I paint in beautiful landscapes, that strike me as being extremely beautiful, in no way invalidates it.

On the other hand it does seem to need some obvious reaction on the part of the painter. This involvement with the world which we surround ourselves with is, after all, borne in on us more and more nowadays. The emphasis on green programmes, environmental health and conservation and so on: we're obsessed with it, I would have thought. The landscape does in fact represent something which is in danger of being destroyed. We suddenly see it now not as something that is likely to be permanent but something that is indeed extremely fragile. Perhaps my own view of it has something of that. I wouldn't like to make any special claim in that direction, but if as a result of my painting it helped someone to conserve the landscape, of course I would be extremely happy.

Most of Worth's work of the late 1940s and early 1950s is far removed from any pastoral vision. It is largely figurative and urban in character, very much in the spirit of the times. The 'Kitchen Sink' painters and neo-Romantic figurative artists like John Minton and John Craxton were in vogue, and Worth was undoubtedly affected by this. Other things were happening in his life. He

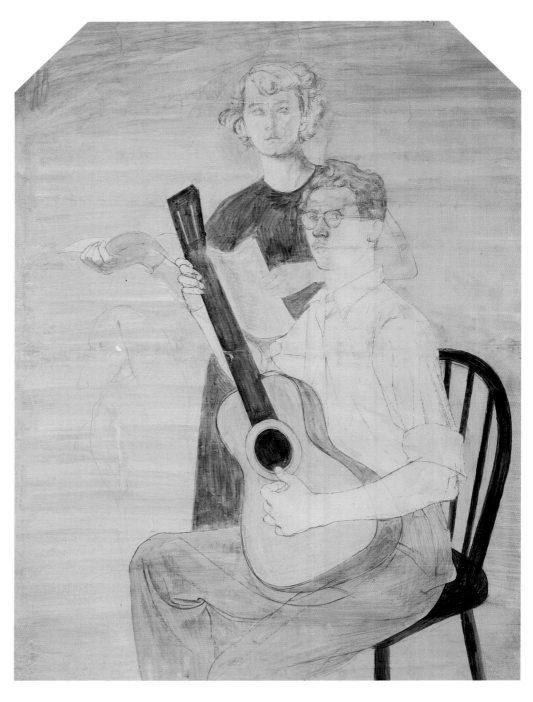

The Concert (c.1950)
Pencil and wash, 40 x 29 ¹/₂ in (101.6 x 75cm)
private collection

had met the painter Jane Taylor at the Royal College and in 1948 they married, having settled the previous year in Epsom, where Worth had secured a post at the Art College. He was to go on to become Head of Fine Art there, before taking early retirement to paint full time in 1979.

In another large pencil and wash drawing of about 1950 entitled *The Concert* we see the couple in front of a mirror. Worth strikes a pose with a curiously stringless, fretless guitar. He is a skilled classical guitarist and his craftsman's interest in the instrument's construction might have had something to do with the condition of this one.

On leaving the Royal College of Art after World War II, Worth had found that peacetime did not bring with it many exhibiting opportunities for a young painter. So he had taken a job as a

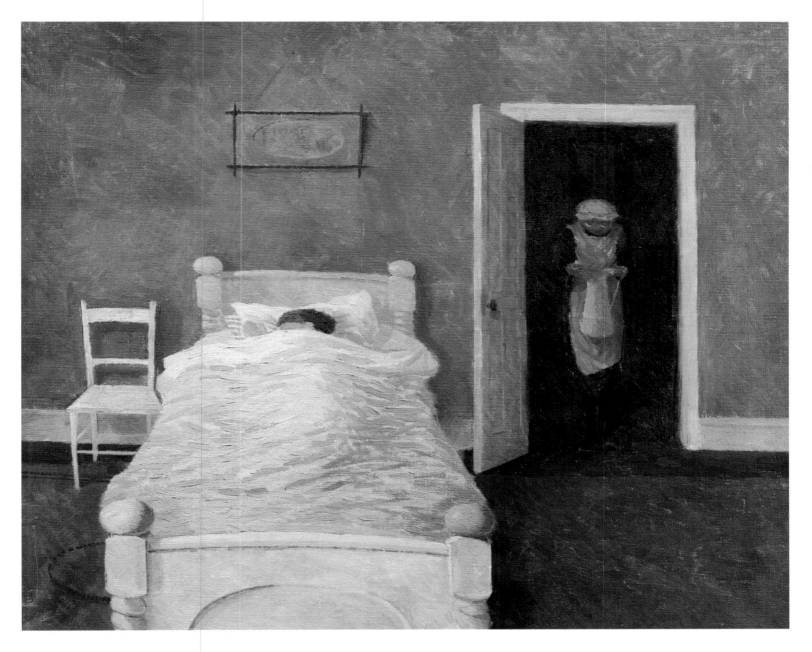

designer for the publishers Jarrolds of Norwich in the autumn of 1946. Painted in retrospect in 1949, after he had moved to Epsom, *Norfolk Morning* recalls his time in digs while working for Jarrolds. This interesting and amusing picture is evidence of Worth emerging with his own language as a painter. On a raking, theatrical set he depicts himself in bed, asleep, but about to be woken by the landlady Miss Clark, a distant cousin of Henry Moore, bringing a jug of hot water for his morning ablutions. Apparently Miss Clark did not think much of her cousin's work, and would impress her views on the young man. The effective, rather acid colouring of *Norfolk Morning* may be a recollection of the decorative scheme of the room, or even comment on his feelings about the place, or the landlady. But he did favour sharp colour schemes in work of this date, and the result is harmonious enough. The handling is confident and consistent right across the canvas, and features such as the bedspread are very well interpreted. The design is simple, flat on to the picture plane, and all that is needed to accentuate the humour of the subject.

Norfolk Morning (1949)
Oil on canvas, 20 x 24 in (50.8 x 61cm)
private collection

15

Lighting Cigarettes, dated 1950, relies for its humour just as heavily on the straightforward presentation of the two principal players. Here, the similarity of the two figures' poses and actions is itself amusing: an early example of Worth's keen observation of quirky, less than conspicuous subject matter, and we can share his enjoyment of the rather absurd scene.

From two smokers to two whippets in *Boy and Bicycle*, another painting of 1950. A single-storey, white weather-boarded building occupies almost half of the central picture space. It is seen flat on, like a second picture surface set back from the picture plane. This device was to be recreated in a painting made some three and a half decades later, *The Annunciation*, illustrated on page 105. Against this white background a boy replaces the chain onto his bicycle chain-ring. The artist has selected a composition and combination of vistas similar to those in *Norfolk Morning*. This time the receding vista is to the left, and along it a dark figure, led by two dogs walking in amusing symmetry, comes towards us. Again the effect is theatrical, as if the event were taking place on a raked stage.

Lighting Cigarettes and *Boy and Bicycle* were both exhibited at a Royal Society of British Artists'

Lighting Cigarettes (1950)
Oil on canvas, 16 x 20 in (40.6 x 50.8cm)
Pictures for Schools

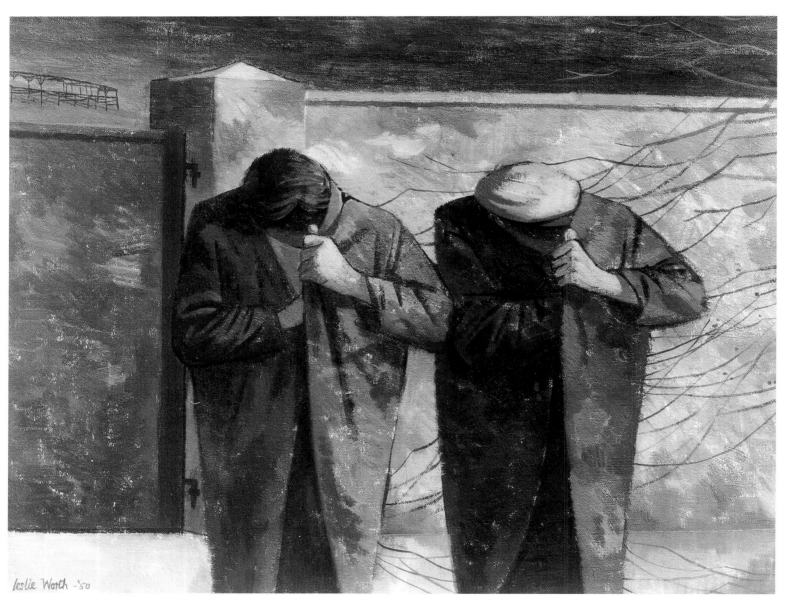

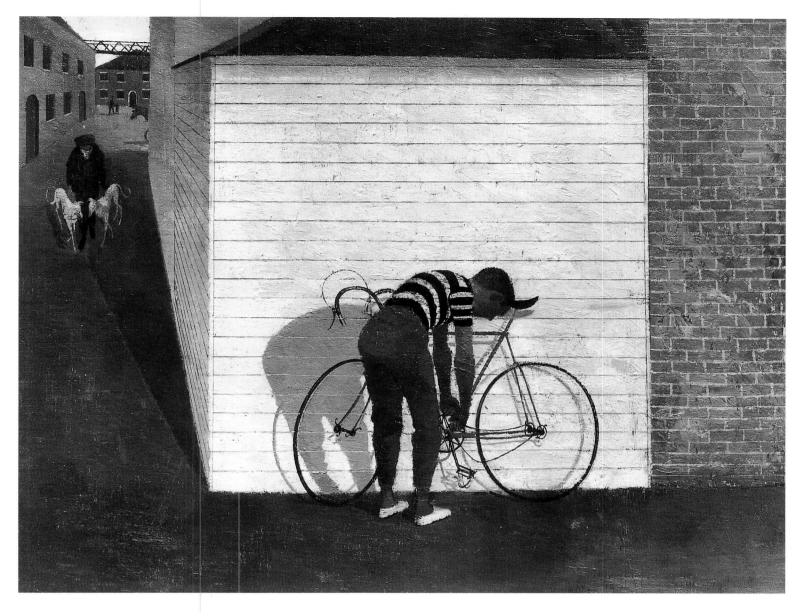

Boy and Bicycle (1950)
Oil on canvas, 16 x 20 in (40.6 x 50.8cm)
Pictures for Schools

exhibition in 1951, and purchased from there by the Pictures for Schools Committee. This was one of the first signs of public recognition, in a career that has seen much. Having exhibited an oil self-portrait at the Royal Academy Summer Exhibition in 1952, Worth's two watercolours accepted for the 1953 exhibition excited the interest of several galleries; Arthur Tooth & Son, Wildenstein's and Evelyn Joll of the aristocratic Thos. Agnew & Son all made overtures. Worth joined Agnew's, having his first one-man show there in 1956, and they remain his dealers.

Over the years Leslie Worth has won a number of major awards and his work has been acquired for several important collections, including those the Queen Mother and the Prince of Wales (who also on separate occasions presented one of his watercolours to President Mitterand of France and to the President of Hungary), and national and municipal collections in Britain and around the world. His book *The Practice of Watercolour*, published in 1977, fast became a seminal instruction book, given the rare accolade of professional as well as amateur approval. It is perhaps the acclamation of his peers that pleases a working artist as much as any other praise, and Worth's election to Presidency of the RWS must have been reward indeed.

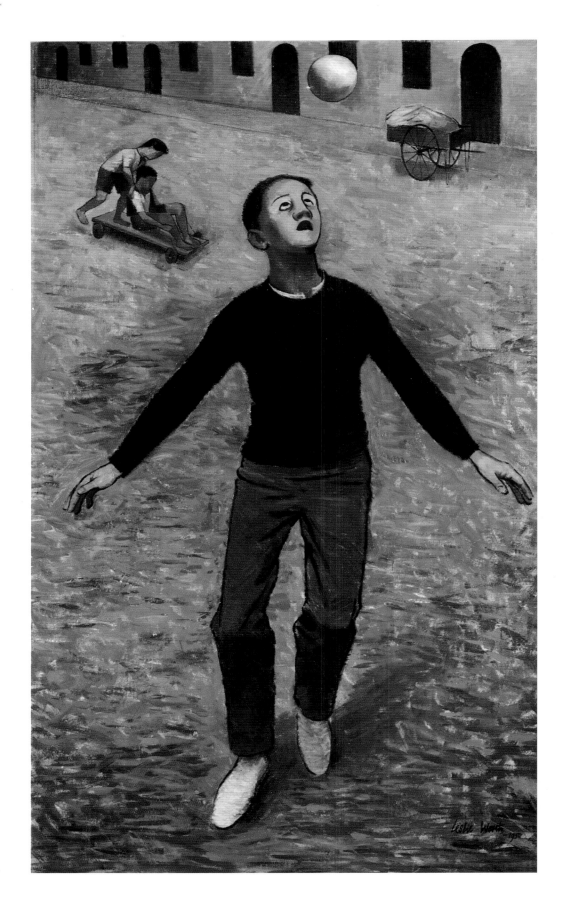

Boy and Ball, Dublin (c.1951–2)
Oil on canvas, 40 x 24 in (101.6 x 61 cm)
private collection

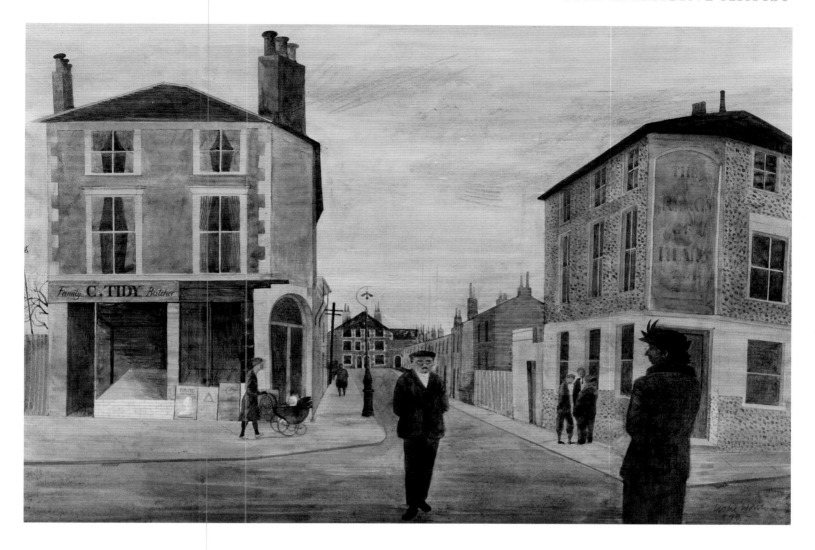

Adelphi Road, Epsom (c.1948)
Watercolour, 14 x 21 in (35.6 x 53.3cm)
private collection

This chapter is concluded with an oil painting of a *Boy and Ball, Dublin,* and the earliest watercolour reproduced in this book, *Adelphi Road, Epsom*. Painted in about 1951–2, the large Dublin street scene is a worthy culmination to Worth's early oils. In a setting reminiscent of the large urban spaces painted by Giorgio de Chirico, a lanky youth heads an emaciated football. The subtle colouring is pleasing, if lacking the verve of the earlier *Norfolk Morning*.

Adelphi Road is slightly earlier than both paintings, probably dating from 1948. Here are the acid colours of *Norfolk Morning* and the precisely delineated, almost caricatured figures of *Boy and Bicycle* and *Lighting Cigarettes*. The street setting is clearly observed and depicted, again in a manner reminiscent of a stage set, or indeed of the backgrounds of Worth's later murals. The tight, dry handling of watercolour is comparable to his contemporary work in oils, as well as to the fashionable watercolour methods of the time, epitomised by Edward Bawden. If there is a presiding influence on this and the other figurative work of this phase in his career, it is perhaps Ben Shahn, the wry American artist and illustrator whose work was the talk of many English art schools in the early 1950s.

But this first illustrated watercolour is an early step on a long road. It was not until the 1970s that Worth's work in the medium had fully developed into his mature style. And it is principally the watercolours of his maturity, arranged according to their themes or concerns, that are the subjects of the sections that follow.

2

THE PAINTER'S LANDSCAPE

Although the subject range of Leslie Worth's mature years is wide, perhaps surprisingly so, he is best known as a painter of the English landscape and coast. Close to his present home in Surrey are the uplands of Epsom Downs. The undulating chalk heath-land and broad vistas from the Downs have, since the mid 1950s, become the artist's familiar landscape. He has continued to walk, study, draw and paint in this landscape ever since. His observations of the weather clearing or breaking in the big skies looking northwards and westwards over the Thames valley have enriched his development as a painter of the elements. Like Constable's Hampstead and Dedham Vale skies, this has been Leslie Worth's weather-painting laboratory.

Floating pigment into water and controlling sweeping washes with immense skill, he has experimented time and again in search of ways to capture the ever-changing nuances of English weather. And, like Constable, like Cotman under the rolling Norfolk clouds, like Samuel Palmer in the Shoreham valley, like Ken Howard in his Cornish studio, Worth demonstrates that the effect of light and weather on a familiar place, which he can by now read like the proverbial back of his hand, facilitates this study.

This has been a journey of discovery, and a significant part of this journey has been the knowledge gained of the spaces, shapes and textures of the Downs. Worth's understanding of form and design, and his appreciation of the spatial and colour relationships that are central to all painting – the abstract in art if we wish to pigeon-hole it – have found an ideal vehicle in the chalk down-land, as they have more obviously in the dramatic coastal scenery we shall see in the next chapter. This observation, the restless enquiry, the noting and the logging of useful information are revealed in a rich series of drawings and paintings.

Being close to home and so well known to the artist, the Epsom Downs appear to feature less

Winter Landscape (1955)
Watercolour, 14 ¹/₂ x 21 in (36.8 x 53.3cm)
Purchased by HM Ministry of Works

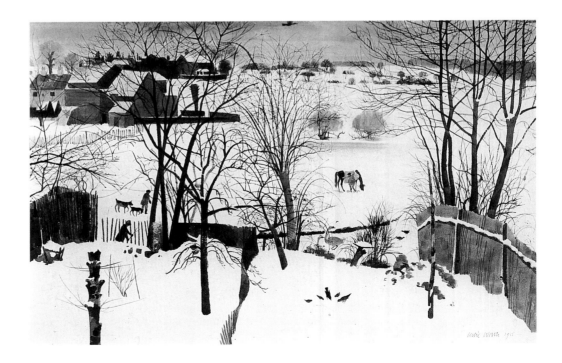

frequently in his sketchbooks than more distant, less familiar places. On many occasions Worth has chosen to carry a drawing board and easel with him and launch straight into large watercolours. We shall see a number of monochrome sketches, but these seem to have been made primarily in a spirit of exploration, in the appropriate material of the moment, rather than as studies for specific paintings.

So, having identified his landscape, we will see how the young painter of street scenes became an artist of the countryside and of the elements. Leslie Worth's interest in the variety of the urban scene and of the quirks of street life, so evident in the paintings of the 1940s and early 1950s, was never to desert him. His fascination with the presence of man and animal within their environment has been omnipresent, even in the 'purer' landscapes of his mature years. Indeed, like the Romantic watercolourists of the early nineteenth century, Girtin, Cox and Turner, whom he so admires, Worth continually shows a liking for the inhabited landscape, however sublime and powerful.

An intense interest in the visual and emotional interaction between man and beast and the landscape also characterises the work of the greatest painters of the inhabited world, from Bruegel the Elder to Constable, from Poussin to Cézanne. It is more than mere coincidence that these great artists also all painted countryside with backbone, massing their forms and designing shapes and linear structures within which the relationship between man and his environment is played out. It is in the light of this great landscape tradition of Western European art that we should look at the paintings of Leslie Worth. We will be conscious too of how his facility with the watercolour brush allows him to emulate the effects of light and atmosphere so effectively captured by the Romantic watercolourists, and now so beloved of today's practitioners. But where so much contemporary, particularly amateur, watercolour painting falls wide of the mark is in the misconception that it can be concerned exclusively with effects of light and atmosphere. The greats, Girtin and Cotman being obvious examples, have looked through these wonderful effects to the form and structure of the land. Worth's landscapes do have backbone and they

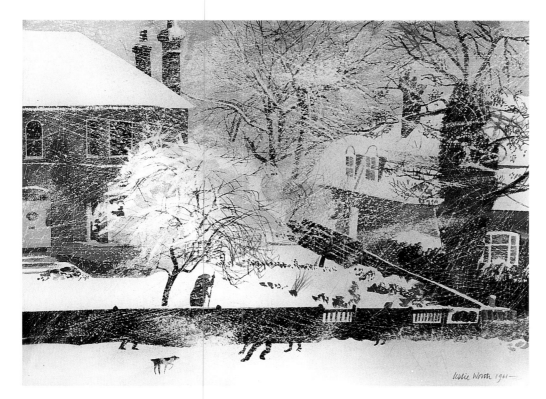

Garden in a Snowstorm (1961)
Watercolour, 15 x 21 in (38.1 x 53.3cm)
private collection

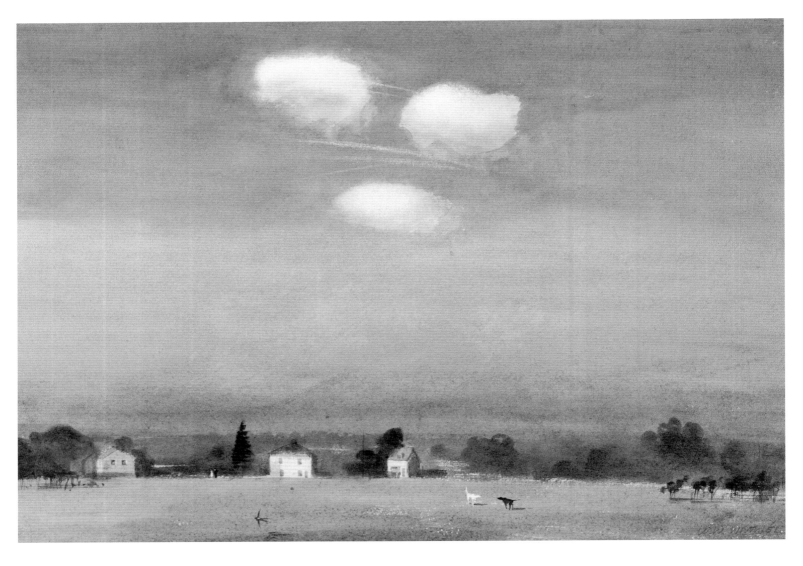

Three White Clouds (c.1951)
Watercolour, 10 x 14 in (25.4 x 35.6cm)
private collection

have design, and they are populated by warm-blooded creatures. We shall see these characteristics in abundance in this chapter.

Emerging out of the urban world of his earlier paintings, Worth's landscapes of the mid 1950s have a distinctly suburban character. *Winter Landscape,* purchased at the 1955 Royal Academy Summer Exhibition by Sir Harold Emmerson for the Ministry of Works, is a reworking of Bruegel in modern Epsom. Bulkily three-dimensional buildings and wandering fences are overlaid with a lattice of bare branches, the whole silhouetted against the even, white terrain. A figure and two dogs go about their business like Bruegel's *Hunters in the Snow*. This dry, carefully delineated watercolour is constructed with an innate sense of flat design that often resurfaces in Worth's art. We will also see both the wintry setting and the interesting motif of a flying bird regularly recurring. Painted in his early thirties, and clearly strong in outside influences, this work does show signs of the artist's emerging maturity, and some evidence of his later characteristic handwriting.

These signs become more distinctive in *Garden in a Snowstorm*, a watercolour of 1961. This suburban scene includes some features similar to those in the earlier work, right down to the silhouetted trees, dog and figures. It also contains weather. If the figures are not throwing snowballs, they are leaning into the teeth of the gale; the blizzard sends snow in all directions, indi-

cated by vigorous and extensive scratching out of the paper surface. As a master technician, Worth's ability to exploit the potential of the paper surface is accomplished and purposeful. Using whatever suitable brushes or other implements that might come to hand, he will pare back or encrust the watercolour surface to obtain a seemingly limitless variety of effects. This method of enriching and enhancing traditional watercolour effects was widely practised in the early nineteenth century, most famously by Turner. Few of today's painters in the medium either seem to wish, or have the technical repertoire, to carry out such extensive manipulation of the paper surface. Nor is such treatment tolerated by some modern papers.

Three White Clouds, probably painted in 1951, is full of life: a white dog and a black dog play out a stand-off, and a swallow wings its way across the foreground. This little painting exemplifies an interest in the pictorial space and lighting of a landscape developing into Worth's art. In 1950 he had moved to a house close to the open spaces of Epsom Common, which beckoned him into a semi-rural community which he much enjoyed. Walking on the Common he started

Richmond Park in a Snowstorm (1969)
Watercolour, 18 ¼ x 22 ⅝ in (46.4 x 57.5cm)
private collection

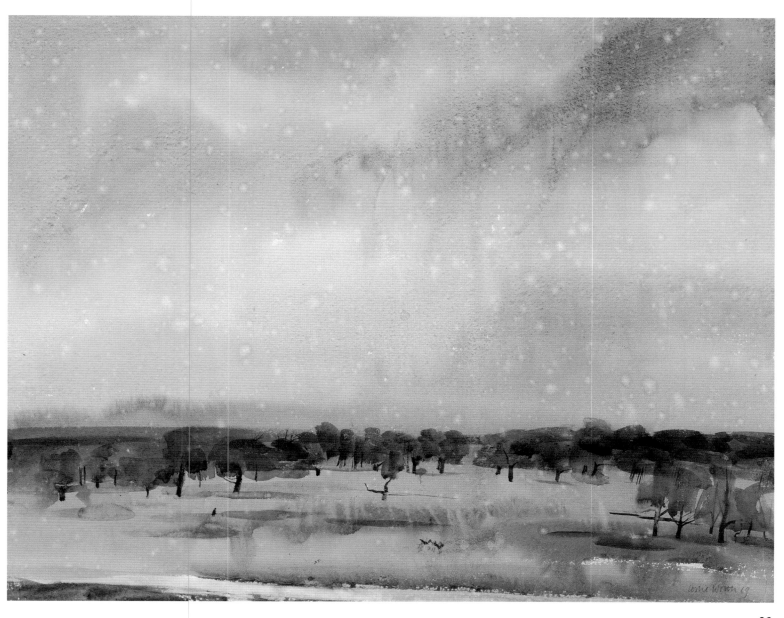

to take an interest in the possibility of painting landscape. *Three White Clouds* is an early essay in the genre.

Although in part painted with a dry brush that just about recalls the *Adelphi Road* watercolour, *Three White Clouds* is largely free of that picture's tight technique. The flatter areas have been tackled with a looser, wetter brush, which helps give a sense of atmosphere and animation to the scene. Layer upon layer of wash has been used to gradate the textured sky, from the urban haze above the horizon, to the clear blue in which the trinity of clouds hover. The careful, almost emblematic placing of these intensely seen white shapes reflects Worth's concern with design and form. The three buildings, catching the sun, echo the heavenly bodies in counterpoint. The white house in the centre stands out like the central motif in Girtin's great watercolour *The White House at Chelsea*.

Wetter still, though to some extent at least, unintentionally so, is a watercolour of Richmond Park, painted during a snowstorm in 1969. It may not have quite the ring of Turner lashing himself to the mast of a ship to observe the raging storm, but the experience produced a simply arranged painting of a 'pure' landscape, worked in front of the subject, imbued with its atmosphere and spattered with 'real' snow. Worth was by now a fully fledged landscape artist. In the 1970s he embarked on an insistent and often revelatory examination of the moods of nature, exploring his landscape with the stylistic and technical repertoire at his command.

The artist's mature style is evident in *A Sudden Shower of Leaves* and *Downs under Snow*, both

A Sudden Shower of Leaves (1973)
Watercolour, 14 ¹/₂ x 21 ³/₈ in (36.8 x 54.3cm)
private collection

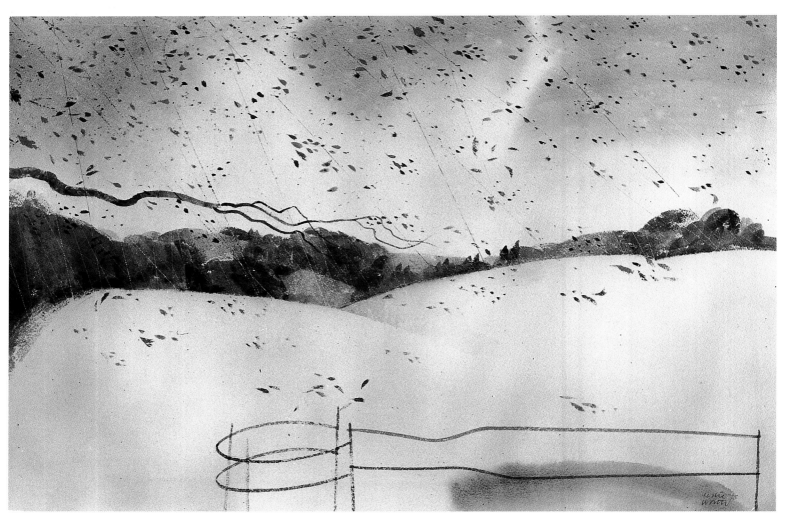

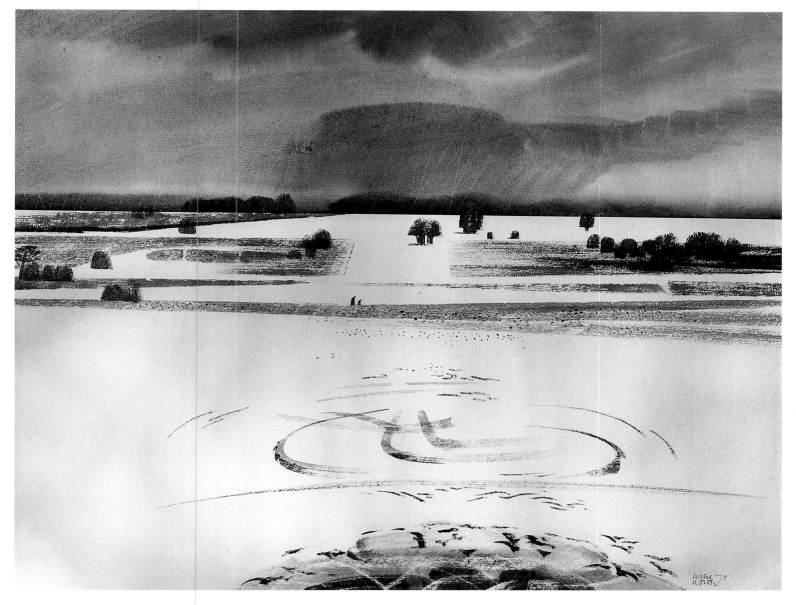

Downs under Snow (1973)
Watercolour, 18¹/₄ x 23¹/₄ in (46.4 x 59cm)
private collection

painted in 1973. Each watercolour is painted with a dry brush, delineating the design over a light background. These are very carefully, almost self-consciously designed sections of the landscape. *A Sudden Shower of Leaves* has a delightful counterbalance of man-made and natural lines and shapes in the drawing of the branch against the fence. This and the dense shower of brush-marks, interspersed with slanting rain scratched from the paper, make for a rich surface texture.

In 1955 Worth had moved to the Victorian house he and Jane Taylor still occupy, close to Epsom Downs, but it was some years before his attentions turned in earnest to this landscape as a subject for painting. The painting of *Downs under Snow* continues the series of winter scenes with which this chapter opened. Its design is defined by the dusting of snow, revealing the bare bones of the down-land structure to create horizontal patterns in the middle distance, and showing up the sweeping vehicle tracks of the foreground. A looming sky is broadly washed with a loaded brush.

Even more threatening are the inky clouds in the beautiful large watercolour entitled *Winter*

Afternoon on the Downs. Although composed with simple horizontal stripes of white paper and expertly modulated deep washes, there is a great sense of space and depth, all the way back from the immediate foreground. The inhospitable scene is patrolled by a lone figure and the central character, a roving black dog. Scraping and scratching of the detailed furnishings of the landscape, grasses and notice boards gives the needed sense of scale and perspective to the middle ground. In the distinctive pictorial space created, we can feel the cold reality of the scene.

Aerial perspective, effected by layering the receding strata of the distant landscape with increasingly pale washes, is the means of giving space and distance to the down-land scene in *The Rift in the Cloud.* This atmospheric watercolour is painted on an imperial sheet, the artist's largest commonly used watercolour format. Laid across the acres of paper the muted wastes have a distinctly chilling effect. This is relieved only by the flight of three sea-gulls, which act as precise co-ordinates within the spaciousness of the snowy middle ground. These birds suggest a sense of life and hope in a blighted, winter world. So too, of course, does the prospect of better weather to come, announced by the white rent in the gloomy cloudscape. This is an evocative, even emotive image.

Perhaps Worth's evident fascination in the effects of dark shapes against snow is most graphically displayed in a series of watercolour studies of a *Dog on the Downs* (pages 28–29), painted in the early months of 1974. This relentless examination of a repeated image is indicative of the artist's inquisitiveness. Leslie Worth explains what happened out in the snow and describes what he hoped to express:

Winter Afternoon on the Downs
(1988)
Watercolour, 16 ¹/₈ x 24 ³/₄ in (40.9 x 62.9cm)
private collection

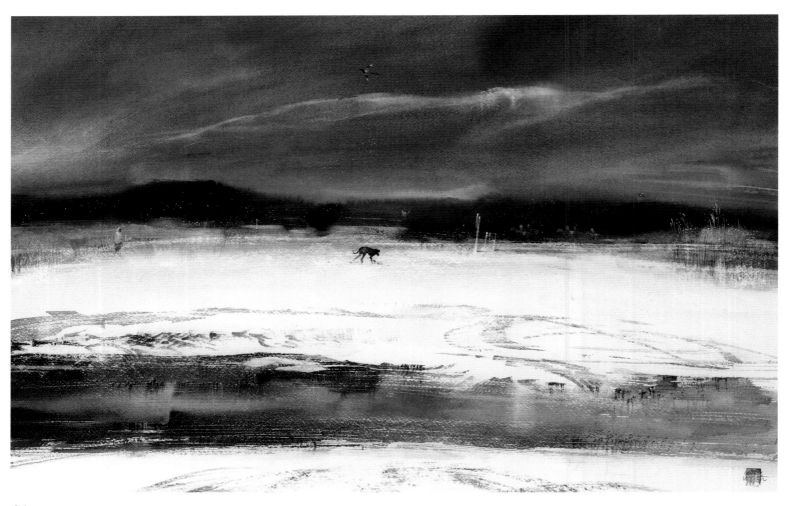

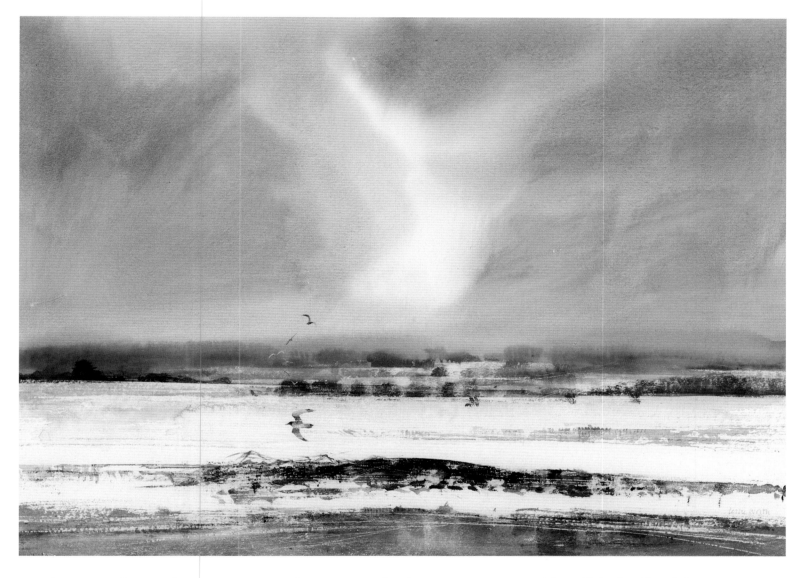

The Rift in the Cloud, Snow-scape
(1989)
Watercolour, 21^1/$_2$ x 29 1/$_2$ in (54.6 x 75cm)
private collection

There was an element of surprise, going on to the Downs armed with a camera to see what might be there, because it was impossible just standing there drawing without freezing on the spot – it was extremely cold – and then seeing this marvellous black animal moving on this great, practically unbroken white expanse. The freshly fallen snow meant that it wasn't even marred by footprints. This huge black animal walking in the virgin white landscape was something that was extremely arresting as an image in itself.

And seeing it under a lowering sky, with a threat of more snowstorms to come, as it crossed a line of chestnut palings, you got this contrast. The formal element of the struts of the fence and then this black animal moving against it was itself very exciting: the two forms together, the geometric against the non-geometric, and the whole thing with a sense of great economy, because there was very little incident to disturb them. There was a bit in the foreground of one of the paintings where partly melted snow produced a sort of pattern, but it was essentially a pattern of the struts of the fence, the black dog and then farther back, at intervals, these little beehive trees against a dark sky. The ingredients were very few and powerful, and something that I never saw again.

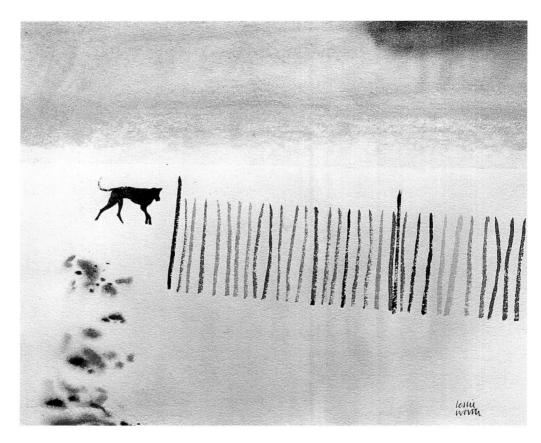

Dog on the Downs IV (1973–4)
Watercolour, 11 x 12⁵/₈ in (27.9 x 32cm)
private collection

Dog on the Downs II (1974)
Watercolour, 11 x 12⁵/₈in (27.9 x 32cm)
private collection

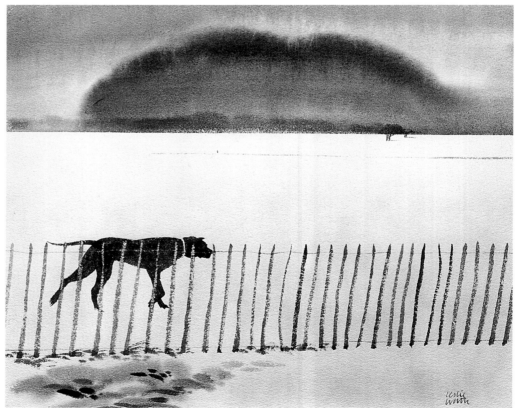

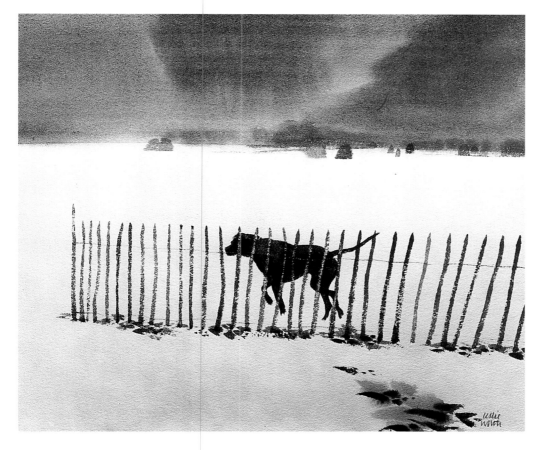

Dog on the Downs III (1974)
Watercolour, 11 x 12⅝in (27.9 x 32cm)
private collection

> It was almost fortuitous, really, that I happened to be there. I didn't go up to paint it, I
> just went up and there it was, waiting to be recorded.

In the three watercolours reproduced here we see the painter twisting and turning the fence, or
rather his angle on it, positioning the dog behind and beside. The flat designs are completed with
a few marks in the melted snow. Using wet and dry brushes on damp and dry paper, he achieves
a range of appropriate effects with real economy of brushwork. The spare abstracted design and
technique, and the flat shapes are all redolent of the apparent simplicity of oriental brush paint-
ing. Worth's interest in Chinese brush painting is evident in his work from the early 1970s, but
it had been with him since his teens, when his favourite painting was *Six Persimmons* by the four-
teenth-century artist Mu Chi. In *A Sudden Shower of Leaves* we saw Worth exercising himself with
the conundrum of carefully placing and composing free brush-strokes. Later we will see these
oriental influences even more clearly expressed.

Storm Approaching (page 30) is a view from the Epsom Downs in Surrey, looking back over the
town and across the Thames valley. The distant dark bulk of the Tolworth Tower, a landmark on
the Kingston by-pass, is seen slightly to the left of centre. This animated watercolour is full of
visual interest. The topography is overpowered by awesome weather effects, but each distant
detail is seemingly set in its own micro-climate, as the elements change across the scene. Worth
here explores and defines the familiar countryside, a distant view he knows so well that the fea-
tures of the landscape and the shapes of the buildings become as second nature, and he can con-
centrate on the natural effects of light and weather which are the subject of the painting.

We encounter more genial weather in the imperial-size watercolour of Epsom Common,
called *Blowing Bubbles on the Common,* painted in 1991. This too is a picture full of weather, or

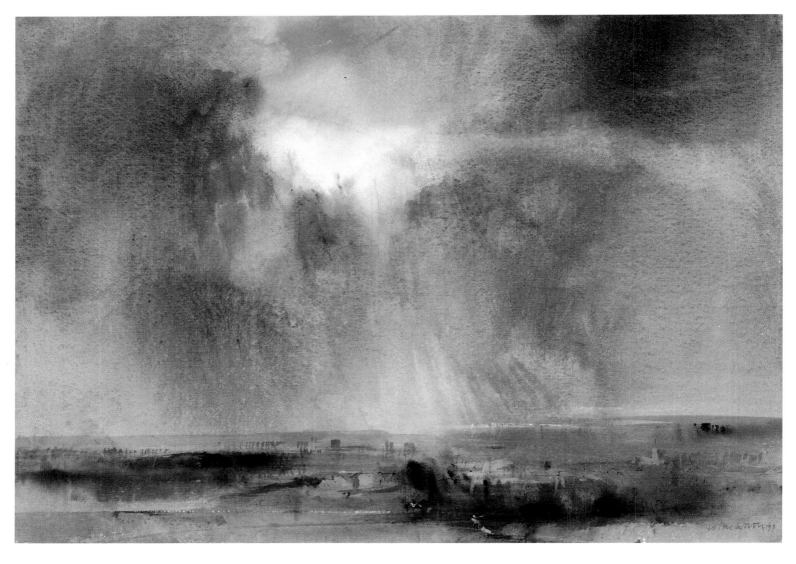

Storm Approaching (1993)
*Watercolour and bodycolour, 13 x 18 ¼ in
(33 x 46.4cm)
private collection*

more properly it is full of air and light. Underneath a rolling sky, a bright and reasonably calm day is suggested at ground level. The almost tangible sense of airy space within the landscape is stunning. The somewhat anecdotal, rather Victorian, theme of the subject does not over-sentimentalise the scene but provides the central focus, without which the landscape would seem empty, its spatial characteristics less well defined and the picture less effective. The whole scene is painted with lucid and always purposeful brushwork. The assurance of the handling is characteristic of the artist's work in the 1980s and 1990s, washing and detailing with apparently consummate ease to create his desired effects. Naturally not all Worth's ventures with the brush appear quite as effortless as *Blowing Bubbles*, but there is no doubt that what is generally perceived to be a very difficult medium does seem to present relatively few problems for Leslie Worth:

> I never found watercolour difficult, contrary to public pronouncements. I am desperately trying not to be immodest about this, but I came to it naturally, that's all I can say. I never had a watercolour lesson in my life. Nobody ever taught me how to paint with it. I sort of knew how I thought it should be handled. I was my own master and pupil, and on the whole we got on quite well together; always bearing in mind what Constable

said, that a self-taught artist had a rather poor master. So one has to have that corrective at the back of one's mind, but to me it was never quite such a premeditated job as painting in oils. However much I painted in oil, all through my early days and right through my college education, it was always more conscious. Watercolour never became quite so conscious. I felt instinctively, I think, what I could do with it.

This affinity with the medium and the feeling that it came to the artist without all the baggage that his strict training as an oil painter carried with it, may have enabled Worth to see the world as comparatively uncluttered and unblinkered through watercolour. It provided a purer, more sensory and immediate language that he could make his own. This should not be understood to imply that his watercolour technique is devoid of references to his early nineteenth century predecessors. From time to time influences from these sources can be cited. At its most profound, this represents a deep understanding and re-examination of the art and working methods of some of the greatest of British painters. At a more superficial level, it is possible to observe that Worth acquired certain mannerisms from the masters of English watercolour. It is probably his own brilliant technical fluency that enables Worth, perhaps unconsciously, to assimilate and

Blowing Bubbles on the Common
(1991)
Watercolour, 22 x 29 1/2 in (55.9 x 75cm)
private collection

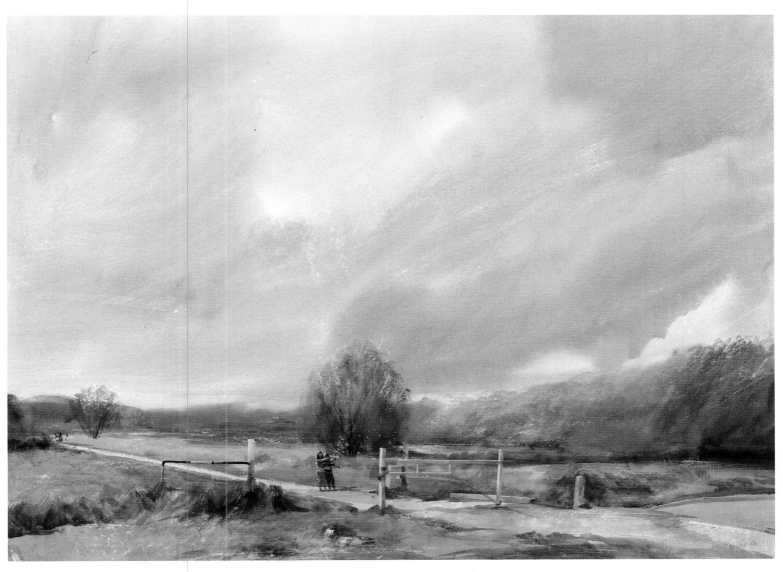

emulate, rather than mimic, the most subtle or powerful achievements of Turner, Cox, Cotman, De Wint and their contemporaries.

Yet this talk of technical fluency and facility suggests that, by the 1980s, Worth had discovered a way of painting without pain. In fact, however instinctive his gifts, this virtuosity with the medium was hard won. And it is not used as an end in itself, but as a means to expressing his reactions to the world around him. Nor are the majority of his watercolours spontaneous responses to what is in front of him. Many of the larger works are based on sketchbook notes, or large charcoal drawings made in the open air. Sometimes there will be a watercolour study, and occasionally there will be more than one version of the same subject, as the artist strives to wring the essence out of his subject. As already observed, a high proportion of the Epsom Downs paintings would have been painted on the spot. But to the observer his working processes may not always appear entirely consistent or methodical. They in fact depend on the requirements of the work, of the subject, and of the artist's preoccupations at the time.

Illustrated here are two sketchbook studies made on Worth's frequent forays on to the Downs. The view of tangled branches and roof-tops (below), with a bird frozen in flight, appears already to be a fairly developed design, with careful notes and tonal gradations to indicate how the distant scene should be painted, one day. The second study, of 'the first day of the thaw, after some days of severe frost', has a classical composition, reminiscent of Claude Lorraine, with the dark, foreground bush suitably placed to give a well-proportioned dual vista. Both studies might one day be useful for paintings, and were probably composed with an eye to this possibility.

In fact the view recorded on the day of the thaw surfaces again, by coincidence and in very different climatic conditions, in an important painting known as *Hot Day on the Downs* (pages 34–5). Here we may see just how successful the composition is. We can also enjoy some glorious sweeps of the watercolour brush, allowing the pigment to roam free, but just under control, across passages of sky and land. The dense tangle of the foreground bush is well described, with rich, deep watercolour and scraping out. And we can almost bask in the warm atmosphere and mood of an English summer's day, disturbed only by the sudden flight of a startled blackbird. Indeed, as if to point out the variations in his working method, Worth executed this sub-

View from Epsom Downs, looking north from the Durdans Estate (1991)
*Charcoal and pen, 11⅝ x 16½ in
(29.5 x 41.9 cm)
private collection*

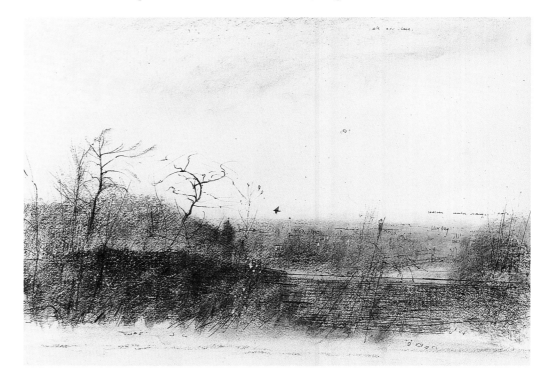

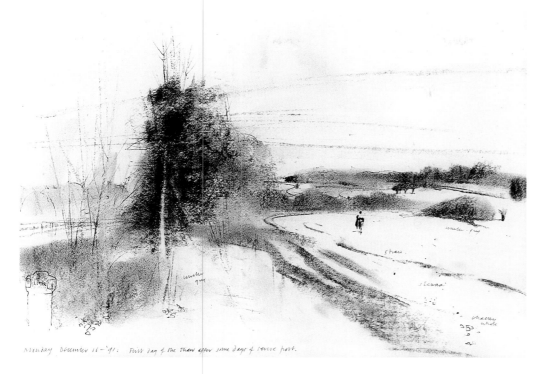

Monday December 16 - '91: First Day of the Thaw after some days of severe post.

First Day of the Thaw (1991)
*Charcoal and pen, $11^5/_8$ x $16^1/_2$ in
(29.5 x 41.9cm)
private collection*

stantial work entirely in the open air. It exudes a sense of truth to nature.

And this leads us on to another rich vein of his working practices, the large charcoal studies sometimes made for their own sake, but often as preparatory tonal studies for watercolours to be made in the studio. Sometimes these studies will provide references additional to the information gained in photographs and sketchbook drawings, and will help further to establish some of the tonal values and relationships within the composition. One such study is an accomplished and elegant view from the Downs (page 36). The use of the soft and expressive medium of charcoal lets the artist indicate, in monochrome, some of the effects that might later be achieved in watercolour. Again Worth is master of his medium. The distant valley for example is as tonally varied and loaded with suggestion as that of any exhibition watercolour. The artist knows the vista so well that representing its nuances of light, form and distance is second nature. Therefore the subject is approached with an ease and familiarity which means he can focus on art, and on drawing light and weather, rather than on topography. The trees are described with no more strokes of charcoal than are necessary, their highlights rubbed out to much the same effect as the scratching out of a watercolour. In its subtle modulations and delicate, naturalistic linear structure, this drawing exhibits the high order of Worth's draughtsmanship. And he also draws his landscape watercolours with the brush, going straight in, usually without any pencil foundation. The ability to tackle a white sheet of paper without preparation transfers well to the bold techniques required of charcoal drawing. Worth patently likes the medium, and had good reason for using it here:

This drawing was not designed as a specific sketch for another work yet to be completed, but was largely drawn for its own sake, although it in fact followed on from watercolours which I had made in exactly that same spot. But there was something about this quality of wintry light, I think, and the contrasts between the linear calligraphy of the trees and the muted tones of the landscape that seemed to suggest charcoal.

Charcoal has got this nice range, I think, from the deep velvet blacks through the middle greys, and it's very evocative: you can lay in a tone. I often work with the char-

Hot Day on the Downs (c.1990)
Watercolour, 21 x 29 in (53.3 x 73.7cm)
private collection, USA

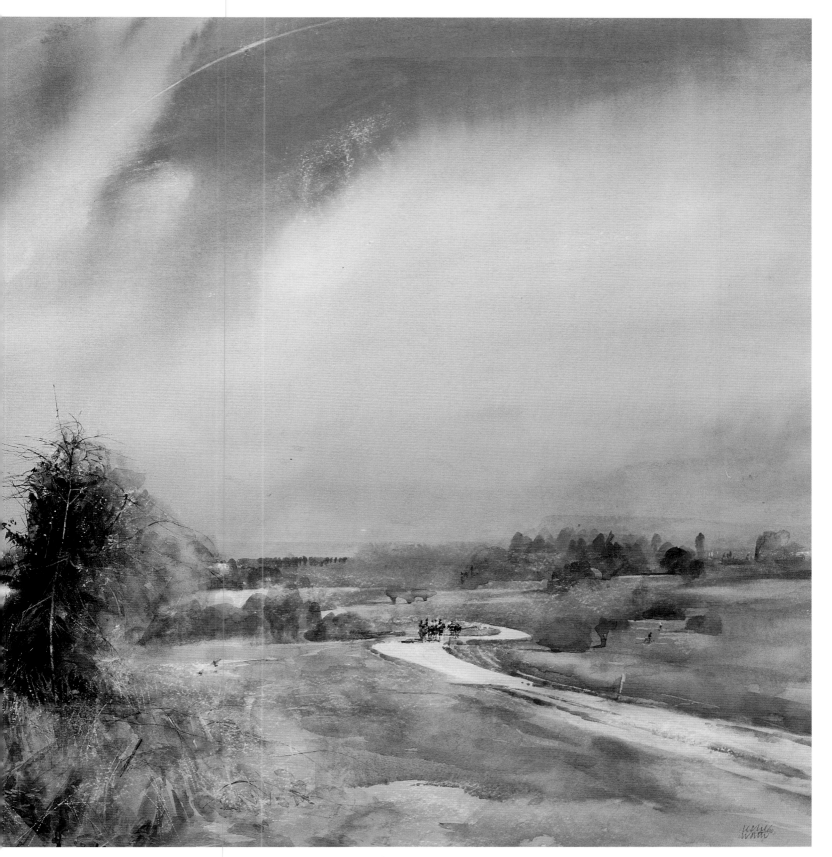

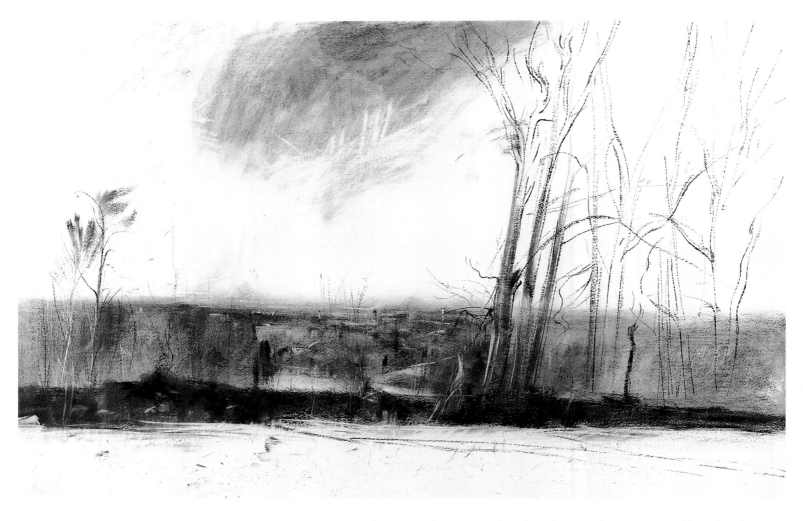

**View from Epsom Downs, looking
north from Downs Road** (1993)
Charcoal, 26 x 40 in (66 x 101.6cm)
private collection

coal on its side and it makes a tone rather than a line. And sometimes I will use the charcoal on its edge, in order to pull a line. And then, if you're careful, you can lift out with a soft rubber and you can recover lights that have been lost. It's a very flexible medium I think. A big advantage is that it's very quick – you very soon achieve what you want.

To compare this lyrical, monochrome study with the last Epsom Downs picture in this chapter, is to jump from one end to the other of the artist's range of work in his familiar landscape. And the contrast is itself evidence of the freedom of thought and visual inventiveness that this very familiarity allows him. In *Hot Day on the Downs* a group of galloping racehorses were to be seen making their way up the track towards us. In *Derby Day*, the left-hand panel of a triptych, Worth tackles directly the reason for the world-wide celebrity of Epsom Downs. On an overcast, and apparently wet, June day, groups of figures loom towards the artist, perhaps on their way home from the races and the traditional funfair.

At the time of writing, this ambitious triptych was in progress and the left-hand panel is shown here in its unfinished state. This gives us the opportunity of an insight into the artist's working methods. At this stage Worth is still slowly building, layer by layer, the overall structure and relationships between the larger blocks of light and shade. In a substantial exhibition watercolour, such as this, the process can be lengthy and somewhat baffling to the lay observer, who might recognise little of the scene before the painter in the blurred shapes on the paper. And then, the various relationships and the tone and colour balance established, the figurative con-

tent will magically start to appear. This reproduction captures *Derby Day* during this transformational stage. The fine drawing of the figures in this panel might surprise those who are not aware of Worth's early oils and who do not think of him as a painter of the figure. What was he trying to achieve in this triptych?

It's an attempt to try and pin down this large parade of figures that constantly moves across the edge of the Downs after the races have been run, and we have this ebb and flow of figures moving as a whole left to right and back again. I simply took a large number of photographs from which I did the drawings. It's almost like a pilgrimage of the families that come from one side, and then go off to the other side to go back to their cars, or to buy refreshments, or to go into the fair. And at the same time you've got the figures moving back to the other side. On the whole the main flow of movement is from left to right, but against that you've got the counter-flow. So there is this endless parade, and I wanted to try and get that sort of feeling of being in the privileged position of being able to jot down a representation of the figures as they went past. It's a very empirical sort of drawing. You don't really know quite what it's going to look like. I didn't know. I had a rough idea of this thing and it seemed to me that it involved a beginning, a middle and an end. So I thought, well it's a triptych isn't it?

It's not very well thought out. I couldn't say what the end would be, but I had a rough idea of the way that groups of people might resolve themselves. I've taken liberties with photographs. I've transplanted figures and so on, and I've tried to bear in mind that it's difficult to get the right scale, because you're not looking at a straight line, but at a slow curve, really. This means that figures on the extreme left are going to be quite small and bunched together and not really discernible, out of which groups emerge, come into focus and then die away again. It's rather like a piece of music that starts with drums in the distance and it gets louder and louder in a curve, hits the high notes and then dies away into the distance. I wanted a feeling of that and tried to keep the movement going if I could, but its success is by no means assured!

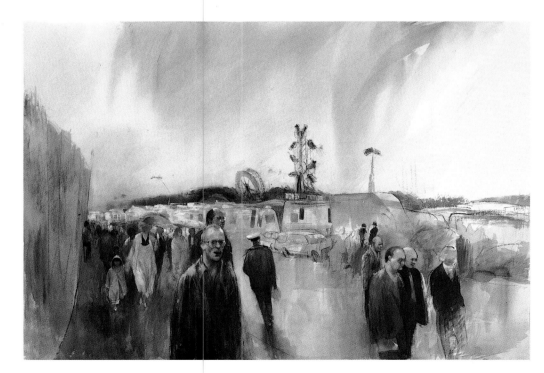

Derby Day (1994)
Watercolour, 31¹/₂ x 45¹/₂ in (80 x 115.6cm)
private collection

Red, White, Blue Red Arrows (1990)
Watercolour, 21$^1/_2$ x 29$^1/_8$ in (54.6 x 74cm)
private collection

Later on we will see examples of the imagery Leslie Worth has found in the suburban streets of Epsom. But as we have recognised, the open, and usually fairly empty Downs constitute his most familiar landscape. It is one that has enough variety – semi-suburban, semi-wild – and enough views to provide him with an ever-replenishing vocabulary with which to speak about his feelings for the landscape in general. The knowledge learnt, the understanding gained could be applied elsewhere. Even somewhere unfamiliar, a landscape, an event, glanced from a moving car, could be read, absorbed and recreated at will.

Red, White, Blue Red Arrows is the result of this event: a dark late summer's afternoon on the A303 carrying the traveller westward over Salisbury Plain and past Stonehenge, a livid, low sun touching the land, a distant roar and a plume of coloured smoke. A glance, a snapshot, a memory, and, back in the studio, the whole experience is recaptured in brilliant, fluid washes, just kept in check. The sky is shot through with the smoke trails of the Royal Air Force's acrobatics team. With an alarming flood of washes, Worth has swept the smoke trails up and across the picture space. In what is an extremely free watercolour, the trails culminate in precisely observed streams behind the climbing formation of planes. This gives the painting its necessary reference point, like the two children in *Blowing Bubbles*, which enables us to make proper sense of the space around it. The final touch of some subtlety is that there are actually no planes to be seen, although we are convinced that they are there. The colourful smoke trails in the evening air are what matter and all that need be shown. The result is a watercolour of a rare lyricism, and of a clarity that is born only of the spontaneous:

> The red and blue discharge from the planes was painted premier coup, by loading the brush with red on one side and blue on the other, and striking fast, without retouching, into a damp area. It was all or nothing: no chance of a second start at it if it failed. It worked!

3
ON THE COAST

The son of a navy man, brought up within easy reach of the Devon coast, Leslie Worth has retained an affinity with the life and landscape of the English sea-shore. In recent decades this affinity has translated itself into an immensely varied series of paintings, exploring every aspect of coastal scenery, weather and activity. If his subject matter is anything to go by, Worth still favours the coast of the south-west peninsular of England, although we will also find him working further afield.

The evocative watercolour of *Blue Anchor Bay, Watchet*, Somerset, dates from around 1971–2. Its purposeful, but delicate horizontal washes, bleeding into lighter background washes, help create a gentle, contemplative mood. The misty spaciousness of the scene is emphasised by the placing of the rocks, apparently floating above the wet sands, in which they are reflected. The sense of vastness is highlighted by the great visual distance to the two tiny figures by the sea's edge, who are perhaps shrimping or collecting shells. Straight away we can sense in this water-

Blue Anchor Bay, Watchet (c.1971–2)
Watercolour, 14 ³/₈ x 22 ³/₈ in (36.6 x 56.9cm)
private collection

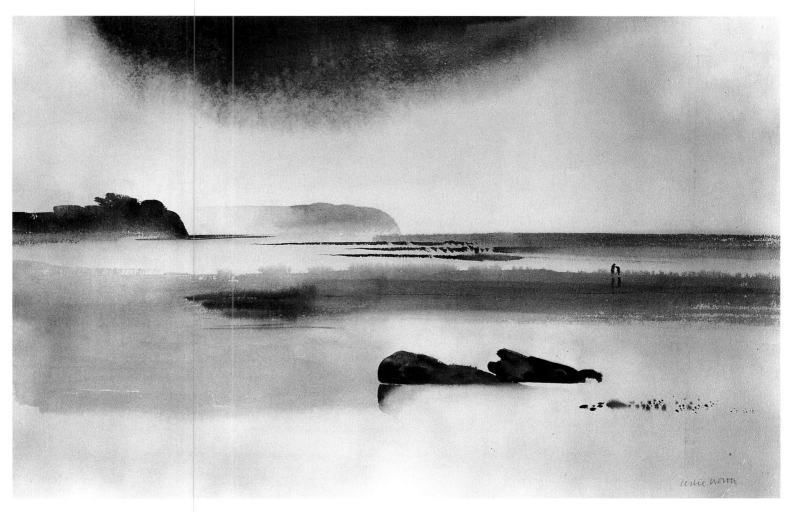

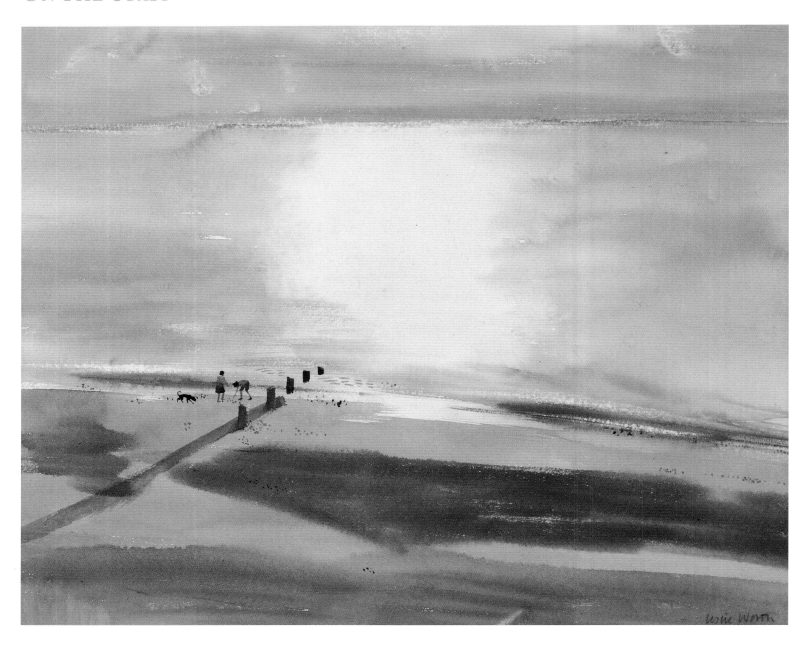

Norfolk Coast (c.1969)
Watercolour, 10 1/8 x 12 5/8 in (25.7 x 32cm)
private collection

colour how at home Worth seems to be on the sea-shore. He sums up the aspects of coastal scenery that particularly attract him:

> Well, it is essentially the light I suppose, the luminosity of the thing that is always there. And also, I think, coupled with that, is the shift in changing moods that is constantly revealing fresh aspects in a familiar setting. I think it's essentially about movement and about change. When I look back on a subject, they've nearly always involved a change taking place: the light is falling, or the sun is breaking through, the tide is coming in or retreating, waves are breaking on the shore, figures are coming and going in the landscape and boats move. It's essentially a non-static, a moving, rather more dynamic sort of landscape, in which the interest lies in seizing the particular, but at the same time trying to suggest the constant change that takes place. You are very aware of the forces

of nature by the sea, and this is not muted by the presence of towns or people, or by landscapes that soften the impact. There is no softening of the impact: you feel cold, you feel wet and very aware of the elemental forces.

In *Norfolk Coast* light floods an open beach, seen from a lofty viewpoint, from which Worth's evident intention was to capture the horizontal bands of shimmering light on the bright sand. This watercolour of about 1969 is stylistically related to other paintings of the period, such as *Richmond Park in a Snowstorm* (page 23) of the same year. It also suggests an admiration of the marine paintings of one of the finest and most enjoyable watercolour painters of the post-war era, Vivian Pitchforth, who, like Worth, was represented by Agnew's. Pitchforth's humorous but sincere paintings of shipping and coastal scenes were characteristically handled with an effective combination of flowing washes and dry brushwork. With this method he searched, usually successfully, for surprisingly subtle atmospheric effects. The contrast between wet-in-wet washes and drier passages was a trademark of the artist, one which Worth has apparently appreciated in the making of this watercolour. Most of the flat areas of sea, sky and sand have been painted with free, wet washes on damp paper. But passages that call for more highlighting or detail – the horizon, the sea gently lapping the shore, or the darker stretch of beach – have been brushed on to drier paper. This allows the paper surface to show through, creating a crisper, more sparkling effect. Within the abstracted flat washes the only detailing is around the

Lyme Regis (1986)
Watercolour, 14 x 21¹/₈ in (35.6 x 53.6cm)
private collection

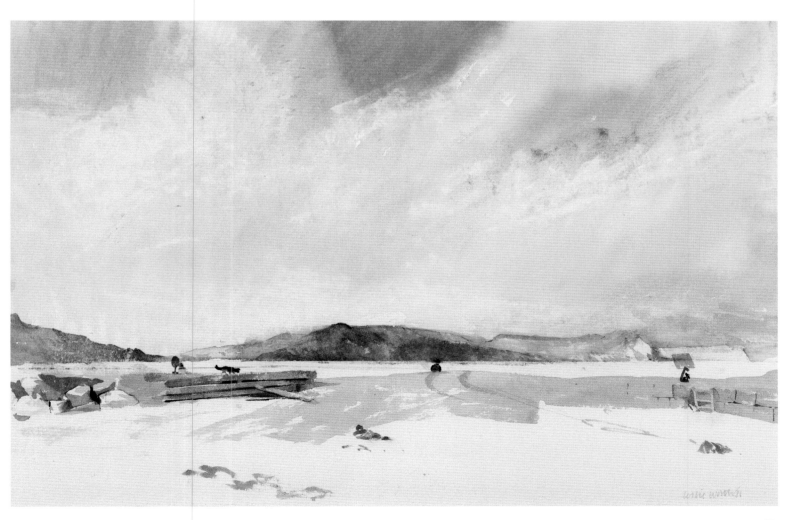

breakwater, where two children, and the ubiquitous black dog, scrabble around in the sand. They form a suitable point of reference within the open spaces of this pleasing watercolour.

Crisper still, and more spare in its handling, is a scene on the beach at Lyme Regis (page 43), painted in 1986. The ancient Dorset town is a favourite haunt of the artist and the subject of a number of watercolours. Here, Worth looks up from a low viewpoint, over a near horizon and on across West Bay to the ridge of Stone Barrow and Golden Cap. The foreground, littered with the detritus of the coastline, is composed and executed with stunning economy. The contours of the ground are indicated by a few judiciously placed brush-strokes, otherwise leaving the paper sheer white. There is a sense of almost meditative deliberation about the placing of the artist's marks that is reminiscent of the care an Eastern brush painter or calligrapher exercises in placing an apparently 'free' stroke of the brush. Watercolour is a medium that is supposed to be unforgiving. But many, if not often admitted, are the professionally painted watercolours on robust sheets of paper that have gone into the bath for a wash or two before finally yielding the desired effect. Plain unpainted white paper is, however, pretty unforgiving. Once a brush-mark is made on virgin paper the painter is committed, unless he is prepared to wash the whole sheet. Leslie Worth is not relying for his effects on the happy conjunction of water and pigment, but

North Cornish Beach (c.1969)
Pen and wash, 10 ³/₄ x 14 ³/₄ in
(27.3 x 37.5cm)
private collection

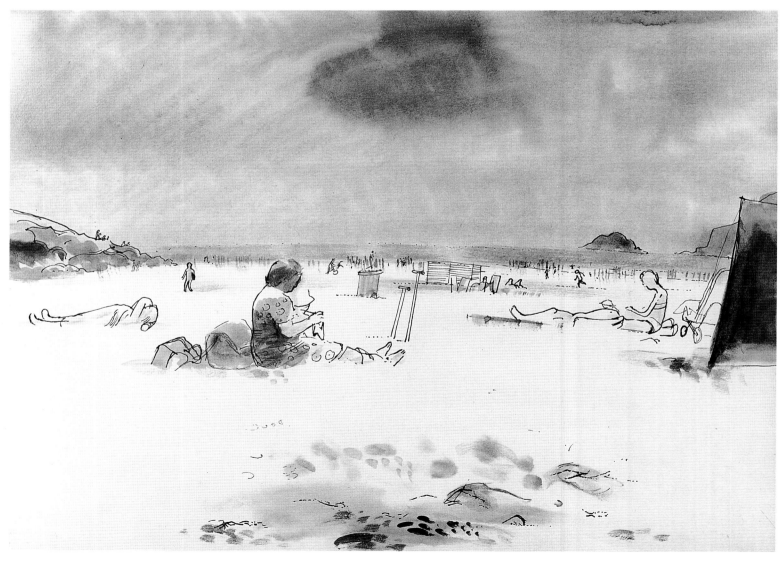

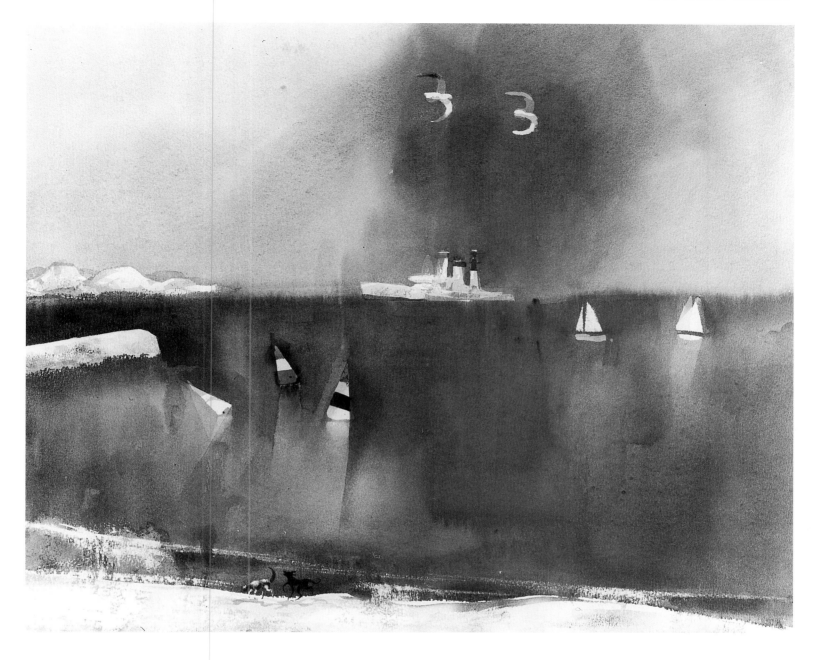

Frigate in the Bay (c.1986)
Watercolour, 15 x 18 in (38.1 x 45.7cm)
private collection

concentrating on the precision of his brush skills. In *Lyme Regis* little is left to chance. Once again reference points play a part in the composition. A dog prowls across the near horizon and, along with a collection of signs, masonry and other features, helps to establish the spaces and distances in the picture. In the centre, beyond some tyre tracks, a figure carries our gaze across the bay towards Bridport. A comparatively 'complete' sky only serves to emphasize the economy of the foreground.

In a pen-and-wash sketch of a beach in north Cornwall, holiday-makers and beach furniture are the principal subject under scrutiny. Under a changeable sky people walk, cycle, run, sit and sunbathe. In the foreground a plump lady in a floral dress carries on with her knitting. This is a real artist's bread and butter, made as an exercise in observation, capturing characters, light and space in a few strokes of pen and brush.

For a continually curious and observant artist like Worth, this sort of study is as much an

expression of a natural language as a self-conscious effort to make a work of art. The sketch was almost certainly made without any further drawing or painting in mind. But once made, it joins the stack of single sheets and sketchbooks in the corner of Worth's Epsom studio, and remains available for reference. Who knows when it might prove useful?

The rather off-beat, holiday atmosphere of the sketch is echoed in a colourful watercolour of about 1986, *Frigate in the Bay*. Painted with intense blues, the watercolour is heavily stylised. The formation sea-gulls set a mood which the jauntily angled sails of the windsurfers and the dancing step of the two dogs affirm. The sharp-edged reflections of the sails bring to mind the Cubist-inspired watercolours of that elegant American painter of the sea, John Marin. Planes of strong colour and deep, granular brushing give the work a structural strength that really underlines its jovial air. That French master of intensely enjoyable seaside pictures, Raoul Dufy, might not have found fault with the result.

The incidental activity of the coastline is a theme in Worth's art. But his interest in the vast structures and spaces where the sea meets the land, and the elemental forces that affect them, runs much deeper and has resulted in some of his most outstanding work. This ranges from large, sharp watercolours of massive cliff and rock formations, some of which take on the appearance of predatory animals, to the most subtle, broadly washed evocations of light and atmosphere. The range is generously wide and sometimes surprising. Illustrated below and opposite, slightly larger than life, are two tiny, jewel-like finished watercolours of figures by the sea. Although small in scale, these pictures are elemental in design and subject. Sea meets with sand and rock, painted with a monumentality that belies the dimensions of the paper sheets, and in between these forces stand insignificant and impotent human figures. Leslie Worth describes how these, and other little gems, were conceived:

> Sometimes these come from a different source. In other words I have sometimes, in the past, chopped up what I've considered to be a failed watercolour and used a bit of it, and it's started to suggest something else. It might be a bit of the foreground that somehow suggests a rocky landscape or suggests a coastal view or something like that. And

Two Figures on a Beach (1990)
Watercolour, 3 x 4 in (7.6 x 10.2cm)
private collection

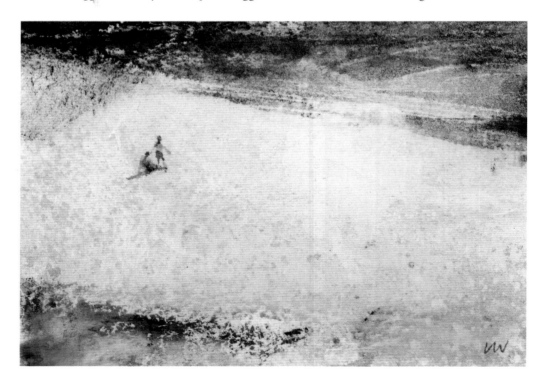

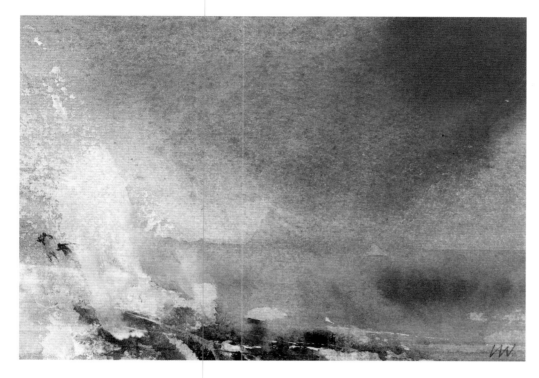

Wave Breaking (1990)
Watercolour and bodycolour, 3 x 4 in
(7.6 x 10.2cm)
private collection

often it will trigger off an idea on the paper that only needs to be drawn out. I've done quite a lot like that, letting the accident of what's there on the page start to suggest a possible picture. But that's not starting from an idea: 'Ah yes I will do a man with a dog by the sea'. It somehow starts to look like it. The way that the washes have accidentally gone together just needs a bit of steering, as it were. That is a source for some of these works.

Having said that, these were done in a little series of half a dozen or so. One or two of them started by accident. Others were started by simply putting colour together to see what it suggested. I am pretty certain a lot of Turner's work was done in exactly the same way, because I found the same sort of things were happening. This is particularly where colours are drifting into other colours, or there are areas where you skim the brush across and you have missed bits and it becomes a sort of rocky profile somewhere in the middle distance, and you can work back into that. I quite like doing that; it exercises one's ingenuity to try and create something out of a series of accidental marks.

These larger than life reproductions retain the imaginative dynamics of these watercolours. They also show off to advantage the raw beauty of the artist's brushwork. To be able to suggest such elemental energy, and such large spaces, over such a small area of paper is an extraordinary achievement. Technically speaking these are miniatures, an art form that takes in Nicholas Hilliard portrait jewels of Elizabethan noblemen as well as landscapes painted on the lid of snuffboxes. In such works the perceived achievement of excellence is the intricacy of the brushwork and the detail incorporated in the work. Even Turner's vignette illustrations, to Samuel Rogers's *Italy* for example, can be described in such terms, as well as containing exceptional descriptions of space and form. But the raw energy and power of Worth's brushwork on such a small scale, smaller than most of Turner's famous bodycolour paintings on coloured paper, is a rare and dazzling thing.

The subjects of *Two Figures on a Beach* are drawn with a precise brush, as precisely described as the figures in a crowded Canaletto. A sense of space, and of awe at the wonder and power of the

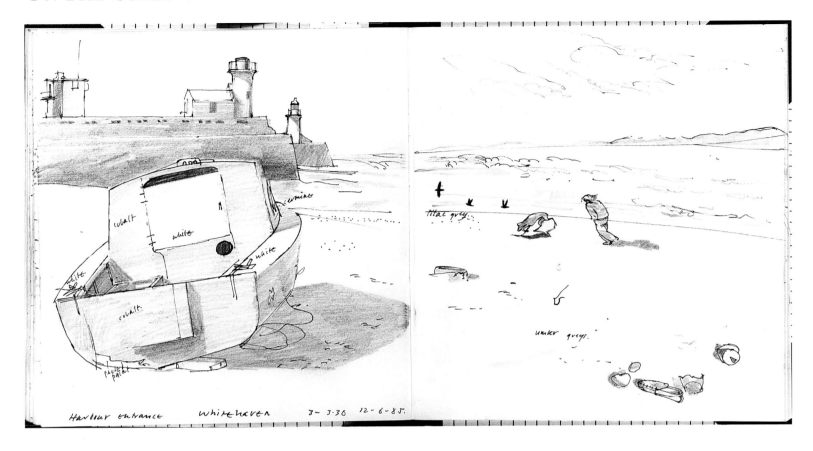

The labels on the sketch read: *cobalt*, *white*, *white*, *white*, *cobalt*, *ermine*, *Harbour Entrance*, *Whitehaven*, *8 - 3.30*, *12 - 6 - 85*, *titac grey*, *umber greys*.

Harbour Entrance, Whitehaven (1985)
Pencil and pen, 8 ¹/₈ x 14 ³/₄ in (20.6 x 37.5cm)
private collection

sea, is expressed by the standing figure as much as it is by the powerful washes and brushwork. On top of the watercolour the artist has worked some dry, dragged brushwork, both to enrich the colouring and increase the textural richness and drama.

Wave Breaking also reveals a complex technique, with watercolour, bodycolour, and stopping and scraping out. Even more abstract and elemental than its companion, the drama here is really in the power of the handling, as much as in the cowering posture of the two figures, recoiling from the 'great' wash of the waves. The watercolour might seem over-dramatic compared to some of the artist's larger works, but on its miniature scale the drama is finely understood and conjured in paint.

Hours spent on the beach undoubtedly provide appropriate moments for drawing in the sketchbook. Yet the study of the *Harbour Entrance, Whitehaven* in Cumbria was not made in a recreational moment. It is one of a series of studies made when Worth travelled to the northeastern fishing port to carry out a commission for oil company Shell UK. The brief was to paint one of a series of the harbours of Britain for the company's 1986 calendar. Worth's was one of seven scenes commissioned from members of the Royal Watercolour Society. Like one or two of the other artists who travelled north in June 1985 to seek out their appointed subjects, Worth met with inhospitable weather. The pencil-and-pen study shows a man, hands dug into pockets, leaning into the teeth of the wind. The waves are driven towards the lighthouse and the foreshore looks like a bleak place. True to the topographical commission the artist systematically records the individual detail of the place, the static elements that characterise this particular harbour. Leslie Worth describes the experience:

Of course time was of the essence. One went up there and within a couple of days or so one had to try and extract out of the whole jumble of visual experiences something

that would somehow crystallise the visit. A lot of the drawings I did I never made use of, because they were largely coming to terms with Whitehaven and what it presented – everything from the quayside and shipping to the rather barren stretches of foreshore. In the end I finished up with the harbour mouth and worked partly from drawings, a lot from the memory of what I had seen, and a bit of photography, which didn't help very much really, to try and pinpoint some aspect of it. But in the end it became this seaside with a heavy swell and a ship trying to come into harbour, and the feeling, I think, of Whitehaven as exposed coastline and the cold, wet time I had when I was there.

The final watercolour was, if anything, even more harsh in feeling than this study of the harbour entrance, and was perhaps less comfortable than might be desired for a corporate calendar. The company expressed pleasure with the result, but the artist's attitude had been uncompromising. The reality of the moment and of the place had been expressed. On the many occasions when we marvel at the virtuosity of the technique, the conjuring with effects of light and atmosphere, it is possible to lose sight of Leslie Worth as a truthful painter of his surroundings. In fact, like

Blue Boat on the Beach (1983)
Watercolour, 10 x 14in (25.4 x 35.6cm)
private collection

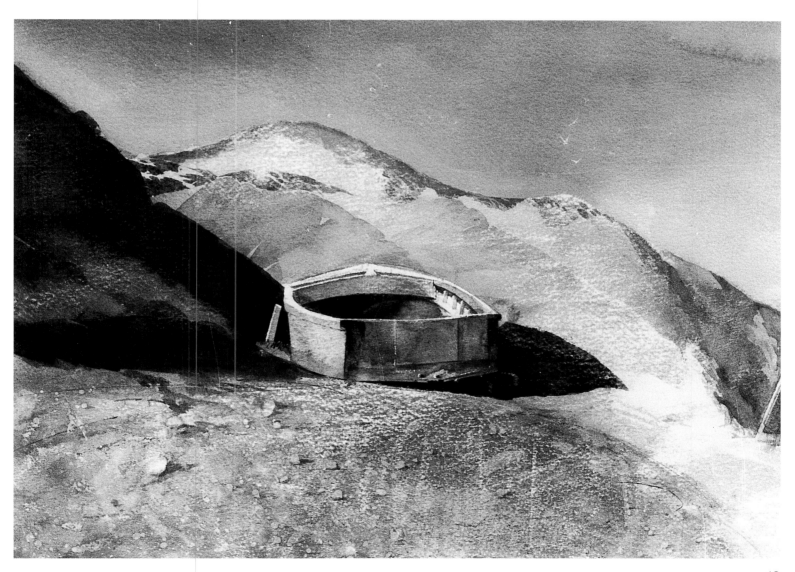

Turner, he will 'invent' extremes of weather or atmosphere for the literary or allegorical subjects we will see in due course, but 'real' landscape will usually only be depicted in weather and light that he has experienced in that particular setting. The shape of the land, or the arrangement of the scenery, might be altered, for what is usually described as artistic licence, but the essence of the subject will be real, natural. If Whitehaven was perhaps uncommonly bleak as Worth experienced it on his one visit to the town, then this is the only way he knows the place and the only way he can honestly paint the subject.

The drawing of the stern of the boat, seen from a difficult angle, is typically assured. In a watercolour of a *Blue Boat on the Beach*, this same unflattering three-quarters perspective on to a rowing boat is at centre stage. The sharpest focus is on the carefully described, beached boat, but equally intensive is the artist's study of the lumpy terrain. Exposed to raking light, the land is crossed by strong shadows. Worth has made active use of the paper's crests and valleys, over which brushes and other implements have been dragged, to recreate the textures of the stony ground seen in contrasting light and shade. The boat sits in the one large, angular area of shade, which accentuates its sharply lit features. Another subject observed in an uncompromising light, *Blue Boat on the Beach* is a powerful image, once seen not forgotten.

Before turning to two more boats out of water, we will look at two fine paintings that include, however small, boats under sail amid the elements. *Camber Sands*, painted in 1991, fits into a small but well established genre of watercolours, of bays being crossed at low tide. David Cox and Turner, most notably, delighted in the potential of this subject.

Camber Sands (1991)
Watercolour, 15 x 21 in (38.1 x 53.3cm)
private collection

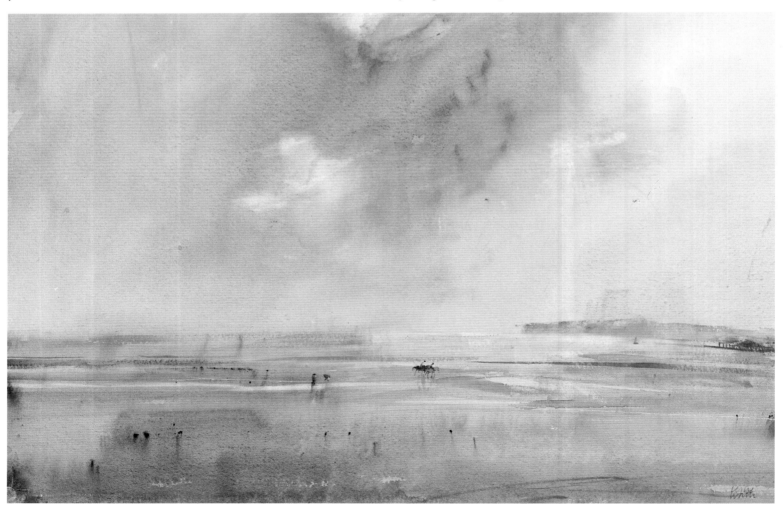

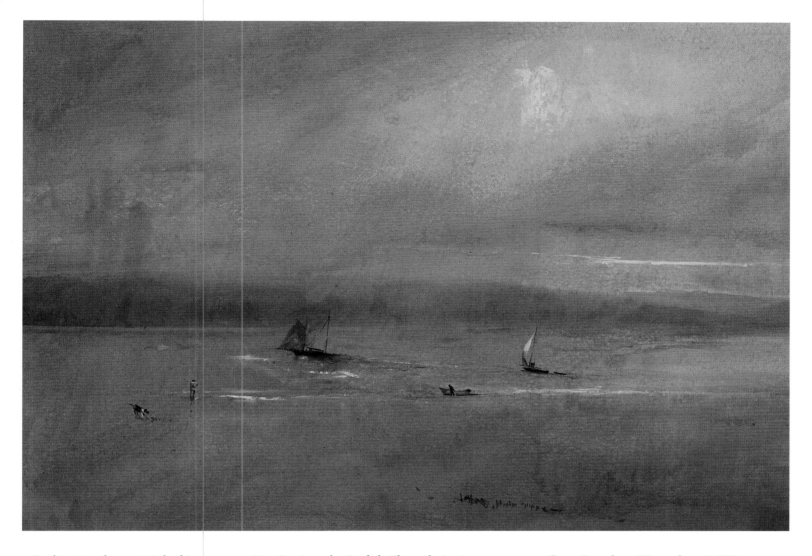

In this view the artist is looking out over Rye Bay into the English Channel. Against a morning sun two figures on horseback cross the foreshore. Along with assorted figures, waders and gulls, their reflections are beautifully caught in the shimmering sands. Apart from some dry brushwork to the right of the beach the whole scene is awash with flowing wet brush-strokes. The artist's wet-in-wet technique has created a misty, luminous sky and a tangible, vaporous atmosphere of distinct beauty. Within the watercolour is immense richness of effect, if economy of technique. The serenity of the scene is enhanced by the simple, almost primal colour arrangement. The centre is dominated by the yellow sunlight and this is flanked by an overall red cast to the right, and the blue of the sea to the left. To be able to record topography, light and atmosphere with such economy is a clear expression of Worth's mastery of his language, and the clarity of his vision.

Even more serene, elegiac in mood, and as subtle as a Whistler nocturne, is a watercolour of a *Grey Evening, Marazion*. Here Worth looks even more directly into a lowering, watery sun, seen looking south west over Mounts Bay, Cornwall. He explains the origins of this beautiful, meditative work, by describing first the value of experience:

> I think a painting is a result of experiences. It may be a cumulative experience, and often not necessarily visual. I think ideas for a painting can come from a variety of

Grey Evening, Marazion (1990)
Watercolour, 22 x 30 in (55.9 x 76.2cm)
private collection

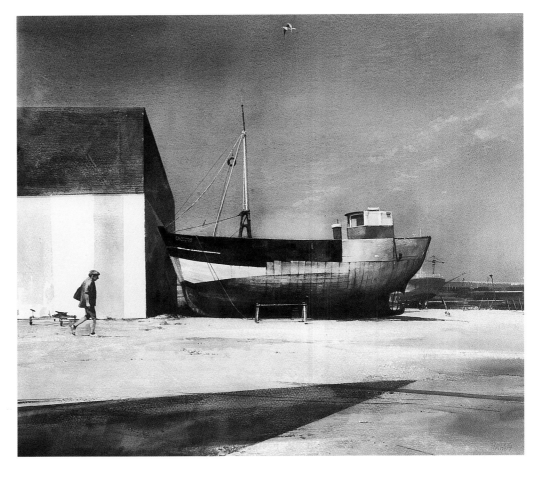

French Fishing Boat (c.1984)
Watercolour, 21 x 25 in (53.3 x 63.5cm)
private collection

sources. Our senses enable us to make sense of the world that surrounds us and we filter the world around us through our senses. So we taste and we touch and we hear things, and that is a terribly important part of a painter's make-up. Amateur interest in art tends to completely ignore this. Amateurs think the whole thing is a visual experience. It often isn't a visual experience at all.

The Marazion painting is a result of walking along the foreshore in the evening, after a rather windy, drizzly sort of day, and the light is low. The only sound I hear is the lap of waves on the beach, and there is the flapping of a sail somewhere nearby, and the distant cry of sea-birds, and the crunch of the gravel under my feet as I trudge across the beach. To me that is very important material to get into a picture. I want to hear certain sounds when I am painting in my memory because that helps to evoke that experience. This is a picture which was done in retrospect. It was not done on the spot because it couldn't be done on the spot. Conditions didn't allow it. At most I would make some drawings or scribble on the back of an envelope.

Memory is the most important thing of all and hopefully one tries to cultivate a visual memory so that in one's mind one relives a particular experience. This painting is a result of reliving it: emotion recollected in tranquillity, if you like. But there are other things that come into it – the craft of the painting, a certain order of precedence that one assumes in putting a picture together. Simply because you remember, it doesn't mean that it is bound to go down as you want. It might have to undergo some sort of transformation in order to accommodate it within a certain framework.

If you look back into the picture, everything is in a state of flux. The light is going;

it is getting darker; the tide is moving, it is receding from the shore which was once wet, and large expanses are still damp; the boats are moving; the dog has discovered something in the sand, and is trying to pull it out; the figure is huddled by the sea-shore, will soon find it too cold and will turn and trudge up the beach to the telly or the pub or whatever. It's all moving; about to become something else.

The two boat portraits reproduced on these pages are more factual, less reliant on recollection and more on record. Only those who have closely seen and observed their subjects can be the best draughtsmen. The almost indescribably subtle curves of a boat's hull are to be experienced in life before being properly understood. Worth here displays his command of line and shape. The intensity, or taughtness, of *French Fishing Boat*, and more particularly of the *Black Boat*, can to a great extent be attributed to the exquisite drawing. In a harbour setting, the French boat is in dry dock, and the surroundings are suitably drily and crisply painted. The gull flying over the centre of the picture, like the dove from the Ark, is a characteristic Worth trademark. But the reference for the well-observed figure would very likely have been a photograph, which would have complemented the artist's sketchbook studies for this studio painting. It is very much a pic-

Black Boat (c.1981)
Watercolour, 21 x 29 in (53.3 x 73.7cm)
Trustees of the Royal Watercolour Society / British Museum

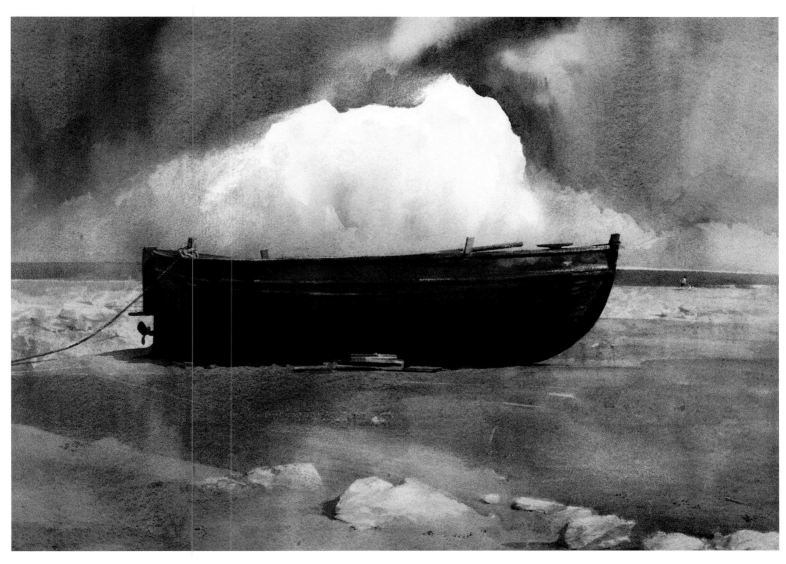

ture of a place, although the powerful design and fine drawing of the hull preserves its integrity as a work of art.

The *Black Boat* is more abstract and intense. The image of the dark boat against an empty beach and seascape is suggestive of a meaning beyond simple description. It would probably be wrong to think of the deserted black boat as a distinct metaphor, although we will see later that Worth is interested in a symbolic or literary interpretation of natural forces and of otherwise inconsequential events. Rather we should simply take pleasure in the potency of this dark, stranded shape, and the glorious white mass of the cloud against which it is set. As emphatically worked and described as the angular terrain in *Blue Boat on the Beach* (page 49), the foreshore is precisely and richly manipulated by the brush and other tools, with the artist's innate wizardry. Now in the Royal Watercolour Society's Diploma Collection on long-term loan to the British Museum, this watercolour was used as the poster illustration for the museum's 1992 display of a choice selection from the collection. It certainly is an outstanding example of Worth's technical and aesthetic power, and it hints at the thoughtful, almost pantheistic qualities of some of his most persuasive painting of the natural world.

A very different, but equally powerful, image of the coast is the watercolour of a broad vista

Cliffs in Sunlight, Flamborough
(c.1980)
Watercolour, 21 x 29 in (53.3 x 73.7cm)
Evelyn Joll collection

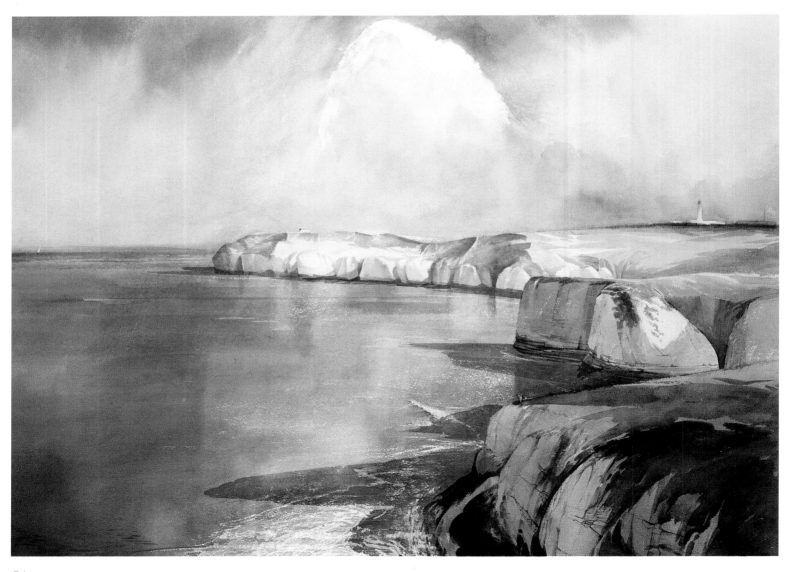

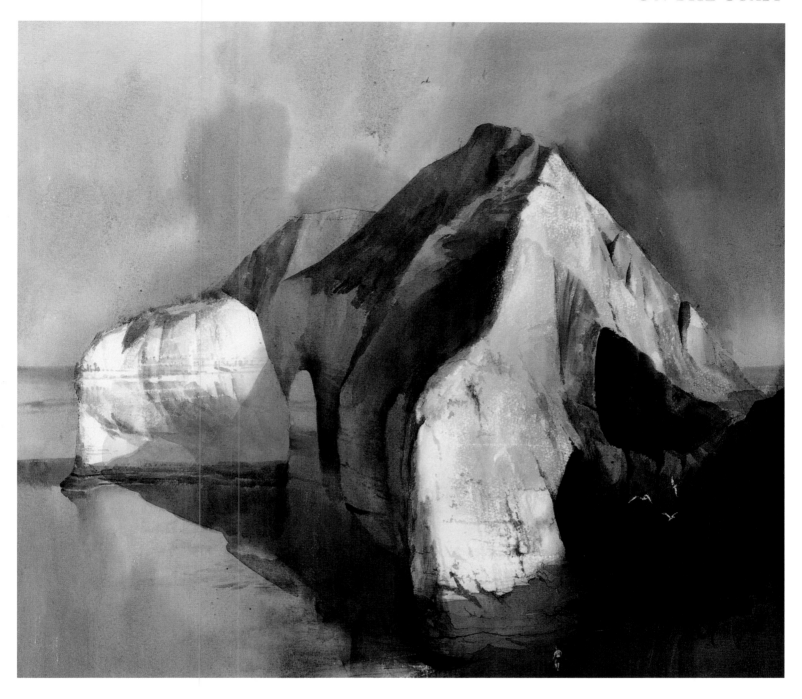

Flamborough Head (c.1980)
Watercolour, 20 x 25 in (50.8 x 63.5cm)
Brian Ingram collection

of cliffs illustrated opposite, entitled *Cliffs in Sunlight, Flamborough*. We are looking towards Flamborough Head, where the Yorkshire Wolds meet the North Sea, between Filey and Bridlington. Above is an even more dramatic watercolour of the vertiginous cliffs of Flamborough Head itself. In these two impressive, large watercolours the artist's examination of the structure, the skeleton, of the landscape is taken to elemental proportions. The monolithic cliffs are rendered with a great sense of their sculptural massiveness, but they are not dead weights. Their smooth shapes and heavy curves are handled as a sculptor might apply plaster to an armature, giving an effect rather like that of skin over musculature. The smooth, anthropomorphic shapes have a feline quality: the line of cliffs perhaps like a crouching lion's paws, and

Flamborough Head itself the animal's arched and tensed shoulders. Both clearly made in recollection in the studio, these paintings are statements about the experience of the scene, the memory of the look and impact of the cliffs in the mind of the artist, and not realist, photographic representations. They could hardly be further removed from Monet's views from atop the cliffs at Etretat, in which the artist's presence in the landscape, the sensation of the breeze in the grass and the sounds of the sea, are all instilled in paint. Worth, by contrast, has seemingly removed himself and his six senses from physical terrain. His vantage point is apparently on a higher plane. Seen from far above, surrounded by sweeping washes, his subject takes on an elemental, ethereal quality.

Cliffs in Sunlight, Flamborough has perhaps more of a generalised, seaside atmosphere, and the more generalised description of the cliffs. In *Flamborough Head*, the head itself stands out in sharp sunlight against an abstracted colour scheme, which brings out the almost hyper-real and quite beautiful handling of the cliff faces. Working into dry paper, Worth has captured perfectly the raking shadows across the left-hand face, describing both the stratification and texture of the limestone, as well as an entirely convincing range of local colour in the shadow. All this is achieved with an economical application of brush-strokes to unforgiving, bare, white paper, together with the artist's characteristic scraping out. In the *Cliffs* watercolour the light effects are rendered with less drama, and most of the scratching out is reserved to describe the white crests of the waves eddying around the foot of the cliffs.

In the *Cliffs* painting, a tiny group of figures on a nearby headland gives a sense of scale, which is emphasised by a distant lighthouse and other buildings. The minuscule, lone figure in the foreground of *Flamborough Head* is highlighted, in vulnerable isolation before the grandeur of the coastline. In the watercolour of *Eve Rock, Flamborough Head*, illustrated opposite, both the human and the canine presence is more apparent, more involved with, and somehow more comfortable in the scene. The white sail, the people active on beach and rocks, all serve to give an impression of compatibility with the still awesome terrain. Again the artist's viewpoint is high and distant, but less obviously removed from the picture space. The giant stacks of limestone that culminate in the phallic shape of Eve Rock are again seen with a sculptor's awareness. Once again also, the lighting is crucial. The strong raking sunlight on Flamborough Head had an extraordinarily dramatic impact on the complex shapes of that structure. Here the less harsh play of a more even light gives the folds in the cliffs a variety of pattern and texture, while emphasising the recession into the middle distance. Within this complex painting the artist has employed a whole repertoire of expressive methods and techniques, as ever dazzling us with his virtuosity. These range from the bleeding of pigment into water below the horizon, to scumbled brushwork over the cliff faces, and scratching out across the sea and foreshore. All this energetic marking of the paper has captured a particular effect of light and shadow, a moment of action and reaction in the air, on the sea and on the land, that will never be repeated. Here is, perhaps, a greater suggestion of Monet's momentary impression than with the more elemental, abstracted vision of *Flamborough Head*.

The black and white illustration helps us to concentrate on the light, tone and handling, at the obvious expense of the colouring. In monochrome the surface textures become more apparent. The considerable range of textures, particularly across the foreground, leaves not one passage of the picture without its tactile interest. We can also appreciate Worth for the fine tonal painter he is. Every passage can be read and enjoyed for its tone. Each detail of this watercolour has abstract, as well as descriptive, intensity and interest, which are testament to the visual energy, curiosity and inventiveness of the artist.

These comments are also praise for the potency and effectiveness of watercolour in the right hands. Worth has seemingly wrung every available effect out of his chosen medium. He has captured the ethereal and the ephemeral, and described the static and the elemental, all with a dexterity and fluidity of technique that are a natural gift, combined with a lifetime of experience

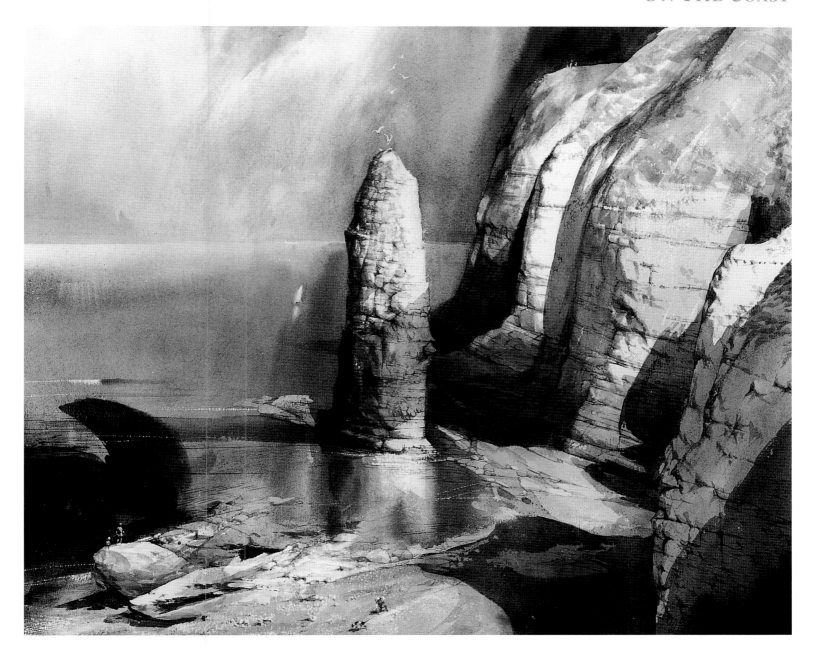

and practice of the art form. Worth's appreciation of the advantages of his medium is always generous:

Eve Rock, Flamborough Head (c.1990)
Watercolour, 17½ x 21 in (44.5 x 53.3cm)
private collection

> With its great fluidity, watercolour is quite unique, for all the denigration which it has suffered enormously. And I am more conscious than perhaps many people might be of the view that is popularly held, particularly in critical circles, of its ineffectiveness. And its very Englishness became a point of opprobrium really. It nevertheless has these particular qualities; its great translucency. It is a very beautiful medium which I rejoice in and I do my best to keep reasonably unclouded, not always successfully. It also has a curious quality which no other medium has of this ability to hold transient effects in perpetuity. It can convey things that have just happened or are about to happen more

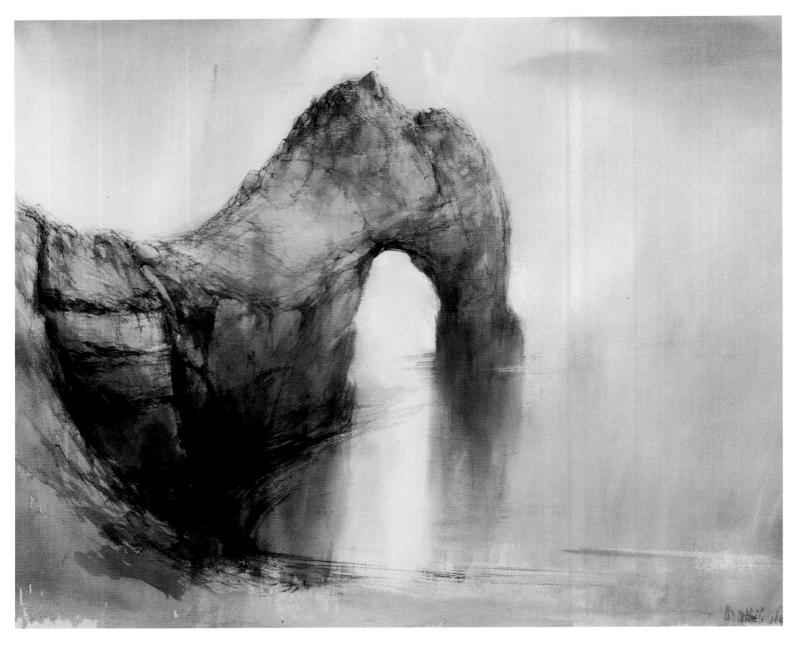

Durdle Door (c.1983)
Watercolour and chalks, 22 x 27 in
(55.9 x 68.6cm)
private collection

eloquently than any other painting medium that I can think of. It has a great ability to suggest arrested movement.

Using a limited palette of blues, yellows and ochres, Worth rejoices in the ethereal qualities of watercolour in a painting of *Durdle Door*, the massive buttress projecting from the cliffs of the Isle of Purbeck, close to Lulworth Cove, on the Dorset coast. At low tide this really is a door from one beach to another. Less overtly spectacular than Flamborough Head, it is nevertheless scenery of some majesty. All trace of human presence has been removed from the picture by the high tide, and yet the sense of scale is in no sense diminished.

We are now perhaps even closer in spirit to Monet at Etretat. There is in its immediacy and spare, free handling the sense of the sketch about this large work. And, with the foreground sweeping round to frame the massive arch within a simple, but pleasing composition, we can

appreciate precisely where the artist is standing. We can indeed join him there.

Making a wealth of spiky marks with the brush and coloured chalks against broad liquid washes of pure colour, the artist juxtaposes the harsh and rugged stone against a glorious space of pure, abstract light. The use of pencil or pen marks to give further shape and texture to watercolour is an age-old technique, dating back, in the current context, to the 'stained drawings' of eighteenth-century topographers. But the application of free, gestural marks, or complimentary or contrasting colour, is a method seen to great advantage in the late water-colours of Turner. Subconscious or not, this influence on Worth's *Durdle Door* would seem incontrovertible. The technique is assimilated, and more importantly used with an unques-

The Blue Grotto (1992)
*Watercolour and bodycolour, 21¹/₂ x 24¹/₂ in
(54.6 x 62.2cm)
private collection*

tioned effectiveness. In particular one could single out the gorgeous passages of blue and ochre drawing from the highest point over the arch and down over the far edge of the buttress. The subtle touches of ochre pencil, where the rocks are caught by the yellowing sun, are a magical touch.

We end this chapter on a far away cliff-top. By comparison with the spare brilliance of *Durdle Door,* the sweeping archway of the *Blue Grotto,* on the south coast of Malta, seems overworked. Bodycolour has been piled onto the uppermost surface of the arch, giving power and weight to the roof of this fantastical grotto. Here, too, we can appreciate exactly where the artist is perched over a plunging drop. A pleasure craft has brought holidaymakers from Valletta on a tour of the dramatic cliffs on the south side of Malta, an island which appears to tilt into the Mediterranean. The ferryboat looks tiny below us, yet recollection of the scene confirms that the artist has not exaggerated the scale or perspective of his subject.

Having previously paid one brief visit in 1959, Worth was on a Royal Watercolour Society trip to Malta and Gozo, in preparation for an exhibition of pictures of the islands by members of the Society. The bus taking the members on a preliminary tour stopped for a few minutes above this spectacular view. All Worth could have gained in the time available would have been a few notes and a snapshot from which to work back in his Epsom studio. To one who witnessed the scene, fighting vertigo on the precarious viewing platform, it seems to be a very true record.

This Maltese painting brings this chapter to a close in warm climes. Later we shall see how readily this painter turns his attention to a wealth of travel subjects, to foreign landscapes, foreign light and foreign atmosphere. In doing so, Worth will demonstrate both the virtuosity and adaptability of his watercolour technique and, of much greater relevance, the clarity and veracity with which he can assimilate, distil and convey new experiences. Yet this section, like its predecessor, has to some extent been about the depiction of familiar landscape. No particular stretch of coastline is as engraved upon the artist's mind as the Epsom Downs. But over the familiar structures of the English coast we have seen him explore the subtle particularities of the northern, indeed the English, light.

4
BRICKS AND WATER

Vertiginous cliff faces plunging into watery depths, a strong light illuminating their highlights and deep shadow emphasising their bulk, gulls wheeling down from their perches: a description as apposite of Leslie Worth's watercolours of the London Thames as it is of the great coastal configurations of the previous chapter. The Thames watercolours, mainly executed in the 1980s, form a powerful, if relatively short-lived theme within the artist's *œuvre*, and we see them here as a kind of prelude to a series of views of urban subjects overseas.

A watercolour of *Construction Work* in east London, painted in about 1988, is the latest of the illustrated pictures. A study of city brick and stone, of high-rise and low-rise, of complex urban shapes rising above the flat plane of the Thames foreshore, this watercolour reveals Worth's appreciation of the somewhat chaotic, unplanned London river-banks. The scene is a slice of the huge London Docklands development programme, which reached its zenith in the late 1980s. This particular view is taken along the north bank of the river, looking over Wapping towards the City of London.

Worth's grasp of the importance of form and line, and his strong sense of the structure of the landscape and coastline, rightly imply that his appreciation of the construction of the city-scape might be profound. The clear perception of London's characteristic restrained colouring and the soft, yet structural manipulation of its shapes, lines and perspectives are consummately conveyed in this watercolour. Worth describes his interest in London as a subject for painting:

> I think it's the quality of light that you find over the river, and the buildings are complementary to that. It's difficult to describe in words adequately something that has an appeal from a purely visual point of view. Essentially it is the river itself, and the reflect-

Construction Work, near the Highway, E1 (c.1988)
Watercolour, 14 1/2 x 21 in (36.8 x 53.3cm)
private collection

Hungerford Bridge (1980)
Watercolour, 19⅝ x 25 in (49.9 x 63.5cm)
private collection

ed light on its surface. And the contrast too between the very solid, monolithic shapes of the buildings, as against the movement of the water, one very static, the other very active. It sets up an interaction that is very interesting in itself. Take one of those ingredients away and you would be sunk, it would make a pretty considerable difference.

So it is the totality of the Thames scene that attracted Worth, and this is exemplified in the next watercolour, the earliest shown in this chapter. The unconventional view of a pier of Hungerford Bridge from near the Royal Festival Hall presents us with a depiction of an urban cliff face. Under repair at the time, and therefore adorned with scaffolding, the bridge carries the railway south from Charing Cross to Waterloo Station. A footpath from Charing Cross to the South Bank arts complex clings to the east side, the one nearest the viewer. Under a grey sky, the blue-green waters of the coast are replaced by a silvery grey, shaded by dark browns and greens. The shadowed bridge support is described with the wonderfully dank purples and browns of soot-encrusted Victorian masonry. The ironwork itself is a splendid mixture of stat-

ic elements, notably the drawn and scratched out scaffolding and a delicately observed gantry, as against the horizontal bands of blue and yellow, which suggest the movement of trains, rattling and clanking over the river. A boat and figures working below the bridge provide the elements of scale, and emphasise the feeling of a vast sense of space that the Thames gives to the heart of London.

The river is London's greatest physical asset, yet one which historically has been undervalued by planners, and even by ordinary Londoners. Standing on some steps, beside the ashlar pile of the embankment, Worth has descended out of the city hubbub into the neglected river world, where work is undertaken, boats ply backward and forward, and people hunt for treasure or meet their end, unknown to the vast majority of London's people. This strong, angular composition is an uncompromising, no-frills view of a rather grim and secretive world. Painted with a lyrical understanding for its subject and with the artist's ever lucid, economical use of the brush, *Hungerford Bridge* is perhaps one of his unsung masterpieces.

Another way to see London's river is, of course, to secure a high vantage point above it. This is not as simple as it might seem. Thames-side sites have long been valued by corporations, a number of which have headquarters along the river embankment. The viewing areas on top of these blocks mostly either serve a private clientele, or have been closed for security reasons. So for Worth, the opportunity to draw from the recreation room on the eleventh floor of St Thomas's Hospital, while resident undergoing eye tests, was some compensation for the inconvenience of a hospital stay. The room is in the hospital's new building by the south end of Westminster Bridge, opposite the Houses of Parliament. It affords magnificent views up and down river and Worth took the opportunity to make a superb series of atmospheric double-page studies in his sketchbook. Joined together, the panoramic series encompasses the whole of the 180 degree view. Although these free studies were made for their own sake and for what they might offer to any further works, without any particular project in mind, it is not entirely fanciful to compare their qualities with those of Thomas Girtin's magnificent series of *Eidometropolis* watercolours and drawings, covering the Thames panorama from the Albion Mills, beside Blackfriars Bridge. Girtin was the first artist, Canaletto not excepted, who really conveyed the vast light-filled space that the Thames occupies. Worth shares with Girtin his understanding that the viewer perceives space through a reading of changing light effects as much as any appreciation of linear perspective. This quality singles out both series.

On the following two pages is reproduced, at approximately life size, the sketched view west, looking up river over the roofs of the older hospital buildings towards Lambeth and Vauxhall Bridges, and the Millbank Tower on the northern shore. A couple of pages further on (page 68) is the sketchbook view straight over the river to the Palace of Westminster. Worth describes how these works emerged:

> It was useful to explore the views that one wouldn't otherwise get. It started with the view eastward to County Hall, and then I moved round, looking north towards the Houses of Parliament, and finally looking west, round towards Millbank and down the river towards Chelsea. That was the extent of the available view. Gradually some ideas for works emerged, but they were the result of a lot of little drawings in a sketchbook, building up a view of it and then finally honing in on something that I felt was worth developing a bit; the view to Millbank, which became a commission. I also took several photographs from the top to try and support perhaps inadequate bits of drawing in the sketch, and to reinforce the general idea about the lighting and so on. I then did a bit of work on the final picture on the spot.

The westward sketch is a superb piece of draughtsmanship. Working fast and with impressive freedom, Worth surveys and then places on the page only the essential horizontal and vertical

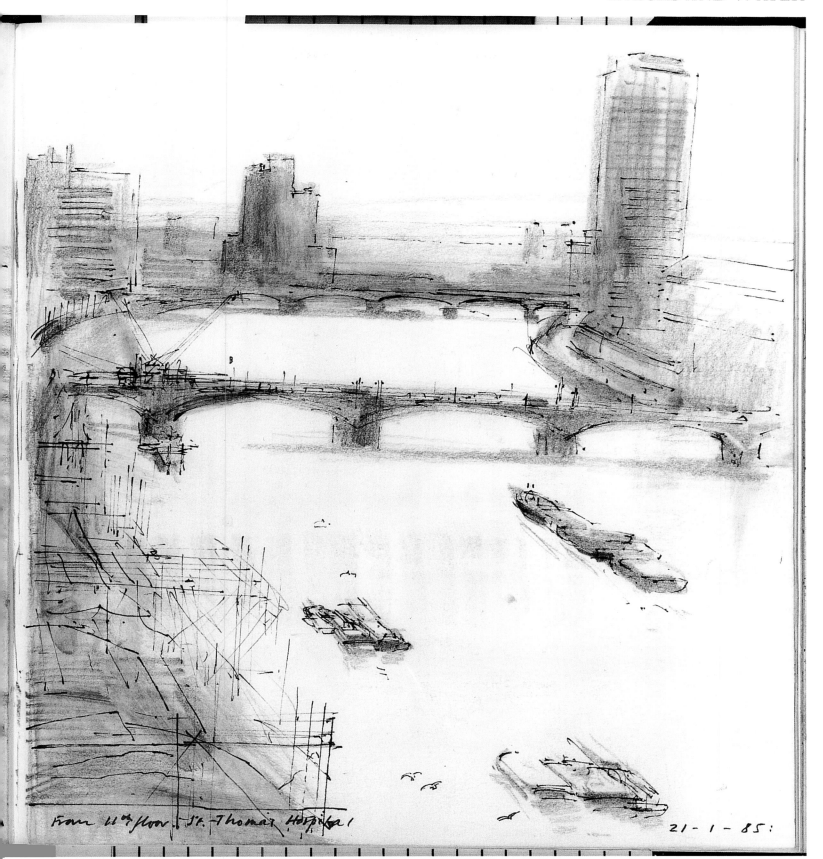

From 11th floor St. Thomas Hospital 21-1-85:

Previous pages:

From the Eleventh Floor, St Thomas's Hospital, looking towards Millbank
(1985)
Graphite pencil and smudging, 8¹/₈ x 14³/₄in (20.6 x 37.5cm)
private collection

Right:

The Thames from St Thomas's Hospital
(1985)
Watercolour, 21 x 29in (53.3 x 73.7cm)
Dr and Mrs Brian Creamer collection

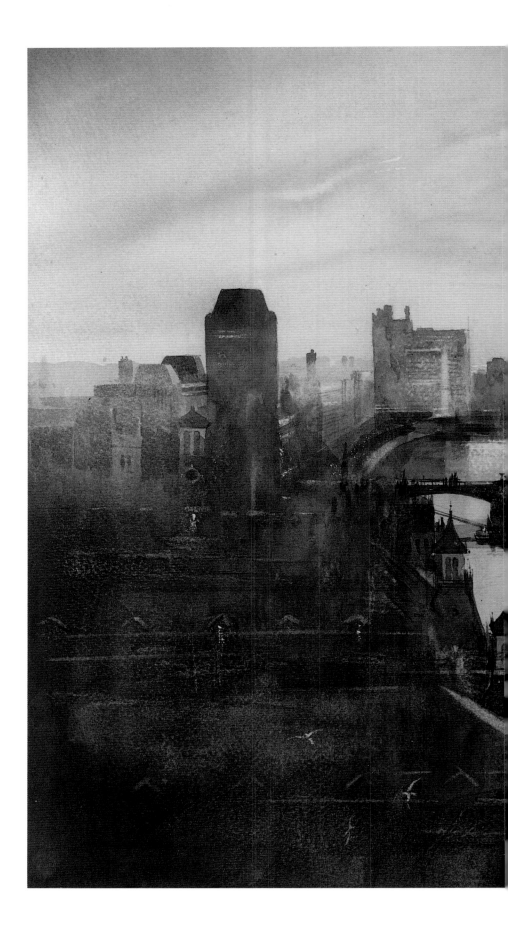

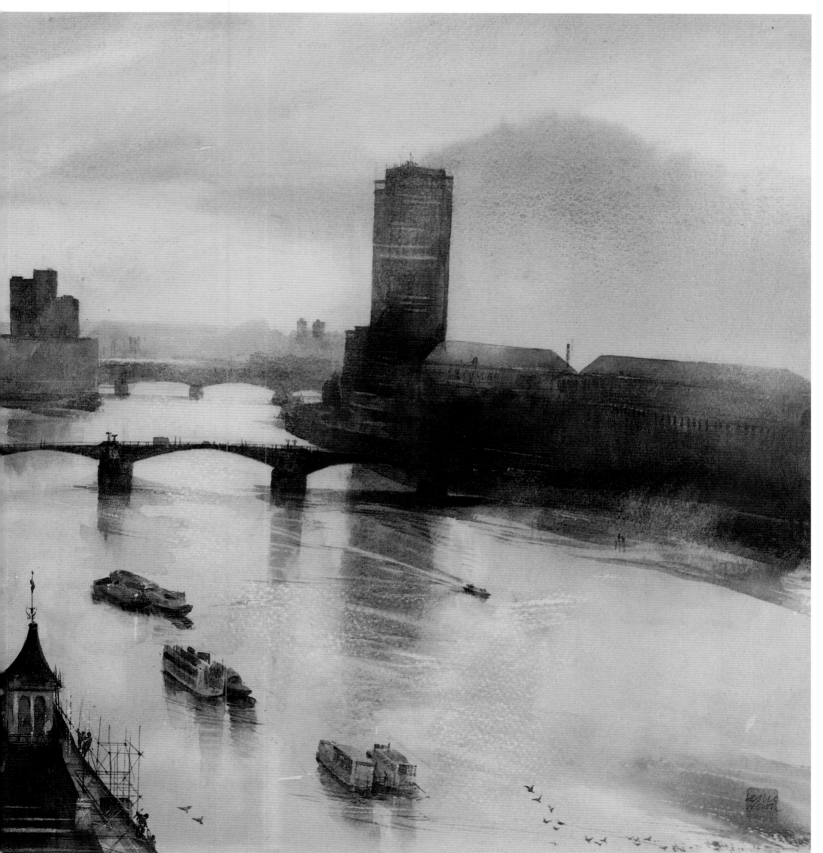

elements of a complex scene. Over a smudged pencil study of the tonal relationships between the principal elements of the buildings and river, he works the most significant architectural shapes and detail in pen outline. These are the actions of a painter who clearly hoped to employ his record as the basis for a painting. As he has said, some additional photographic records provided the additional reference that would be required. So this is very much a working drawing. But it is a very beautiful one, which is complete enough as a work of art in its own right. The painting that did result is illustrated on the subsequent double-page spread and was in fact commissioned on the basis of the sketchbook study by a consultant at the hospital. We might immediately note that the lantern towers on the river frontage of the old St Thomas's were barely suggested in the sketch. It is in such instances, when repetition of, say, an architectural motif within a sketch seems unnecessarily laborious, that photography comes into its own as a tool for the painter. The painting is not itself a slavish copy of any study or photograph, and some licence is taken with the scene, as is demanded by such a visually complex view. But the topography is as accurate as is needed for the artist's purpose.

More importantly this is a painting of the January afternoon light, as the sun slides towards the river and the shadows on the hospital roofs turn a cold, purplish hue. This light, and the very particular London atmosphere, Worth has captured and evocatively conveyed in this watercolour. It is that curious, rather magical moment of a winter's sunset on the Thames, when the light is as strong on the water as above it. Contrasting with this brilliance is the deepening gloom of the city, where the streets, and the buildings on Millbank, have long since descended into darkness. Pleasure boats moored out from St Thomas's and the wake of a launch plying its way downstream help to define the perspective and surface plane of the smooth river. The sheen on the water is very effectively painted, as are the reflections of the pleasure boats. On one or two, lights glow, and their echo in the water is a delightful touch, off-setting the gathering twilight.

Palace of Westminster (1985)
Graphite pencil and smudging, 8 1/8 x 14 3/4 in (20.6 x 37.5cm)
private collection

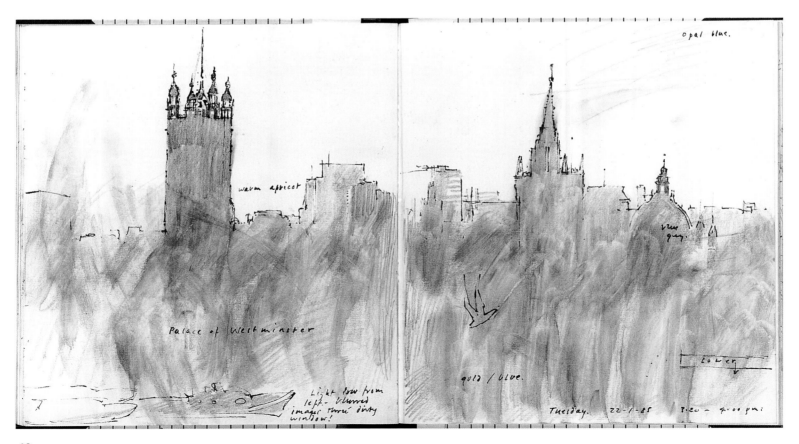

Palace of Westminster (1985)
Watercolour, 10 x 14 in (25.4 x 35.6cm)
private collection

The sketchbook study of the *Palace of Westminster*, directly across the river from the recreation room, was made the day following the previous study. It too is made against the lowering afternoon sunlight. The time is recorded as 3.20 to 4.00pm: forty minutes taken to draw and smudge the study. The Palace is one brooding dark mass, and the architectural interest is in the complexity, rather than the topography, of the fantastical skyline. We see quite a mix of architectural styles, from Barry and Pugin's Gothic Revival Victoria Tower on the left to the classical cupola of Central Hall, Westminster, on the right. The Clock Tower, in which Big Ben hangs, is out of sight to the right of the vista. Like the study made the previous day, this was clearly intended from the outset to be available as a working drawing for possible future use. Worth has carefully indicated the placing and shape of a passing gull, as well as one of the tugs that pulls strings of barges up and down the river, and has made colour notes accordingly. He has also noted that the scene was viewed through a dirty window, producing a blurred image. The apparently random smearing with the finger of the soft graphite pencil is thus explained.

Unlike the view upstream, this simpler image did not give birth to a large finished watercolour. The painting of the *Palace of Westminster*, produced for exhibition rather than commission, is not only modest in scale, it can even be read as a further study. Although Worth has used the architectural reference points of the sketch, and faithfully incorporated the bird and tug, his main interest seems to have been in further exploring effects of light and atmosphere over the river. A refreshing state of experimentation seems to exist.

5
OVERSEAS

Leslie Worth's overseas travels have produced a sizeable body of work: sketchbooks packed with quick jottings and careful records of the life and landscape he has encountered, and finished watercolours, mainly produced in quieter moments of reflection back in his Epsom studio. In Europe he has worked quite extensively in France, Spain and Italy. The first work illustrated in this chapter is a jewel-like watercolour on the small format that seems so appropriate for intense, sparkling subjects. Although not on the tiny scale of the beach paintings seen earlier, *The Grand Canal, Venice* fits well into this category of work. Worth has painted more substantial and less traditional views of the city, such as the impressive and very fine re-creation of *St Mark's Square in the Rain*, illustrated in *Visions of Venice*. But this watercolour, on a modest scale and of a well known view from the Rialto Bridge, might also be one of the most beautiful small water-colours ever made of the Grand Canal. The wide colour range, from the strong accents of the blue canopies to the orange of a motor launch, and from the more subtle, deep colours of the buildings to the vaporous blues and greens of the Canal seen against the light, is an unerringly complete and harmonious arrangement. Leslie Worth describes how he sets out to capture a world on a small sheet of watercolour paper:

The Grand Canal, Venice (c.1989)
Watercolour, 9 x 11 in (22.9 x 27.9cm)
private collection

One tries to think of it imaginatively, that is in the sense of what steps do you take in keeping the background very soft, pushed backwards; getting maximum contrast between light and dark; trying to lay the washes across so that the light spills across the picture and is not just tacked on to the buildings in a hard way.

First of all you would use rather limpid washes that would cover the whole of the paper, going right through everything. And then you begin to plot things. You say well, that's the division of the horizon line to the ground and this is where the block of buildings comes. So you begin to lay in the washes of the canal, running across the buildings, leaving out little things like the figure in the boat until the last minute, and then building more into the block on the right to get more depth into it, to try and describe the distance to the background. Even though it's only three and a half inches [8.9cm] on the page, it's got to be four hundred yards [366m] in the picture. Gradually you are breaking down the washes, isolating little bits that catch the light, like the faces of the buildings which are at a different angle from the other buildings. It's a continual revision and build-up, gradually establishing the identity of the buildings, but at the same time trying to keep them within a block and not pulling at the detail too much; and then finally coming into the walkway in the front, with the shadows, and you're getting some of

La Plaza, Santiago (1982)
Watercolour, 10 x 14 in (25.4 x 35.6cm)
private collection

these dark accents of the gondolas. Now the whole thing is getting a bit of meaning, with the dark tones, the middle tones and the lights. Finally, when you've largely got what you think is the right sort of balance, you come in with the figure in the gondola.

But it's working from broad, overlapping washes of colour, which are mainly concerned with creating depth and space. I don't make any distinction between a quality of light and of space. You can't have one without the other. I try to destroy the surfaces of pictures. I really try to say: that point on the page is three miles [4.8km] back, not just four inches [10.2cm] down from the top, seven inches [17.8cm] from the left. So I am constantly in my mind projecting beyond the surface of the paper and trying to make a statement which is consistent with that, bringing a sharper and sharper focus in, setting the stage before bringing the actors on.

This description of Worth's methods could be applied to many of his watercolours in this book, although, as we have seen, he is no automaton and treats each subject in an individual and appropriate manner. *La Plaza, Santiago* (page 71), for example, is a larger, flatter, more robust work than the Venetian piece. The heat haze of a summer's day in Venice is swapped for the intense, deep blue of a Mediterranean winter sky. In the foreground a group of local boys slide and tumble on ice that remains in the deep shade at one side of the square. That purple shadow, observed in the midwinter view of the *Thames from St Thomas's Hospital*, is here again giving its cool depth to the area of ice. With the sun directly behind the viewer, shining straight down the length of the square, the two receding sides are also in a cold half-light. The rich, warm sunlight on the honey-coloured stone steps and façades opposite, and the deep blue sky are a welcome contrast. The aquamarine of the sky is just reflected in the dark ice, the surface of which is marked by very appropriate scratches with a sharp implement. In patches the frosty surface is indicated by milky dabs of wet, Chinese white bodycolour, which seem to float over the paving slabs. With characteristic economy, only the visually most pertinent and sunlit architectural mouldings have been elaborated upon. The cold depth of the windows, cast in deep shadow, is suggested merely with brief, dark brush-strokes.

Although on a larger scale than the Venetian watercolour, the dimensions of *La Plaza, Santiago* are still fairly slight. Within its physical parameters, this work is loaded with visual interest and richness. Surrounded by the imposing forms of the buildings, the square itself becomes a tangible and specifically defined pictorial space, a theatre within which effects of light and shade, warmth and coldness interact.

On a larger scale altogether, the artist creates a really vast urban pictorial space in a huge watercolour entitled *The Approach to Brooklyn Bridge*. Leslie Worth's travels beyond Europe have taken him to Australasia, China and North America. We shall see in the watercolours and drawings that have resulted from these journeys the intense visual curiosity that travels with him. On the evidence that we have, the subjects that have caught his investigative eye have been profoundly understood in visual terms. And the life, light and landscape he has found have been assimilated and depicted for what they are, not what the painter might wish, or find it more comfortable for them to become.

And so, at the less smart Brooklyn end of the famous New York bridge, Worth has made an altogether different type of urban painting from the discreet, shadowy Thames views. This is New York: the picture is large, the space is huge, street furniture is predominant, and the station wagon is big and fast. Without it looking too much like the graphical representation of movement in a comic strip, the car is a blur of speed, its wake throwing a screwed-up newspaper into the air. The moving car is the perfect foil to the imposing and stolid bridge gateway. The sweep of the road created by the wide angle of view completes a satisfying composition. No doubt with the aid of a snapshot or two, the receding vista to the left of the scene is painted with

remarkable attention to detail. Indeed the whole picture is treated with an all-over evenness reminiscent of the American photo-realist painters. Once again the artist has found the appropriate means to depict his subject.

As one example of his meticulous approach to the execution of this watercolour, Worth recalls how he depicted that discarded newspaper:

> I painted this detail by screwing up a ball of newspaper, threading it on a length of nylon fishing line, and hanging it from the studio ceiling. By projecting light from a spotlight onto it, I simulated daylight. The painting of this detail took me one and a half hours.

As already noted, Worth did not choose the glamorous, Manhattan end of the bridge. This may have been purely for pictorial reasons, but an interest in the more down-at-heel aspects of the city manifests itself in other works resulting from his New York visit. *Intergalactic Art* (page 76) is the clearest expression of this interest. Apparently unconcerned to be standing, drawing in a run-down corner of the Bowery, Worth has roughed out a powerful sketch, full of movement and vigour. A Rastafarian cyclist passes a derelict block on which is scrawled graffiti, including a gesture of support for the PLO. Over a boarded-up shop Worth records the legend

The Approach to Brooklyn Bridge
(1984)
Watercolour, 25 1/2 x 37 1/2 in (64.8 x 95.3cm)
private collection

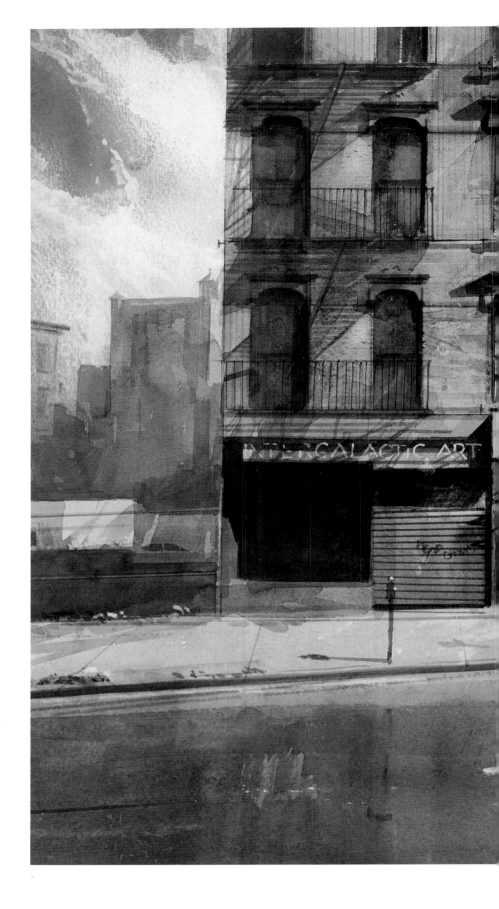

Intergalactic Art (1984)
Watercolour, 13 $^5/_8$ x 20 $^1/_2$ in (34.6 x 52.1cm)
private collection

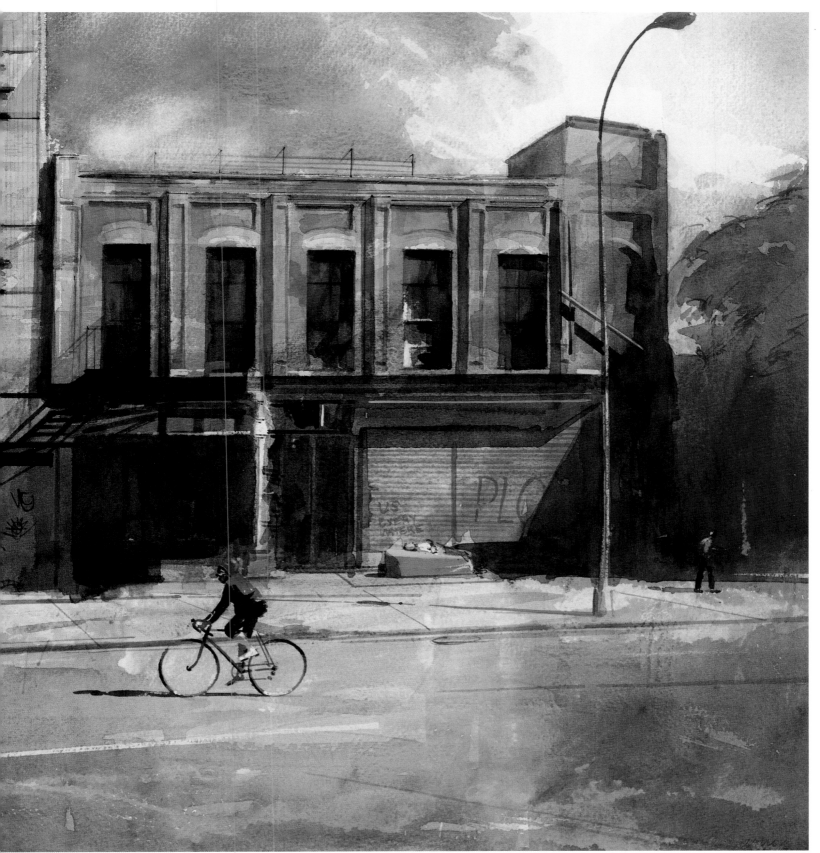

INTERGALACTIC ART
The Bowery – N-York.

Intergalactic Art (1984)
Pencil and pen, 9¹/₂ x 14¹/₄ in (24 x 36.2cm)
private collection

'Intergalactic Art'. Maybe as he stood sketching, far from the more apparently safe quarters (or galaxies) of the city, the artist felt that this rather wacky sign aptly reflected his own state at the time.

Back in the sanctuary of the studio, Worth has revisited the experience in another powerful and carefully detailed watercolour (pages 74–5). The vigorous speed of the sketchbook drawing has been modified into a more stately representation of the boarded-up building, straightening out the lines and adding detail garnered from additional photographic records. As much as anything the sketchbook study has given him the sense, the memory of the place and a record of the tonal relationships which a snapshot cannot convey. But most crucially, and inadequately appreciated in words without experiencing it oneself, the very act of drawing the subject means that it has in some small way become part of the artist, has been recorded inside the mind. It is then ready for if and when that record will be needed again to develop the subject further, or to extend the experience to another subject altogether.

The strongly lit and powerfully moulded forms in *Intergalactic Art* might suggest this is another mammoth watercolour. In fact its picture area is about one-quarter of that of *The Approach to Brooklyn Bridge*, and it is illustrated here not far short of life size. Beneath a bright sky the buildings are drawn with consummate draughtsmanship. Across the richly textured earth colours of the façades, the keen shadows of an array of architectural ironwork create patterns of movement. The deeply shaded mouldings, the irregular levels and roof line, and the variegated colours of the blanked-out windows and doors complete the picture. Worth has taken what, to

many, might be an unprepossessing subject, and has seen in it a wealth of visual interest that, even after the event, we might find it hard to recognise if standing in front of this view. And he has taken it head on, parallel to the picture plane, without any picturesque trappings or interesting perspectives. Only the red-bobble-hatted cyclist relieves the straightforward description of the block, a group of buildings made magnificent in its shabbiness.

Another ordinary slice of urban North America is featured in a sketchbook study, illustrated here, of *A Back Lane in Winnipeg, Canada*, dating from 1983. Drawn in pen and pencil in half an hour, from 10.30 to 11.00am, this study includes enough colour notes to suggest it might have been thought of as potential material for an exhibition watercolour. Certainly the scene composes well, and the artist's attention has been caught by the tangle of overhead wires, as well as the finely observed shape of the back end of an old bus, around which the general clutter of a backstreet anywhere completes the scene. Essentially a line drawing, this is an excellent example of how much can be delineated and described with relatively few strokes of a pen. Again Worth has chosen a collection of assorted objects that many painters might reject as too mundane. How does he come to choose subject matter that one might think of as outside the realm of the archetypal topographical artist?

The short answer is that it chooses me rather than I choosing it. Simply by keeping one's antennae rather alert, and being alive to what's going on around one, it naturally pre-

A Back Lane in Winnipeg (1983)
Pencil and pen, 9 1/2 x 14 1/4 in (24 x 36.2cm)
private collection

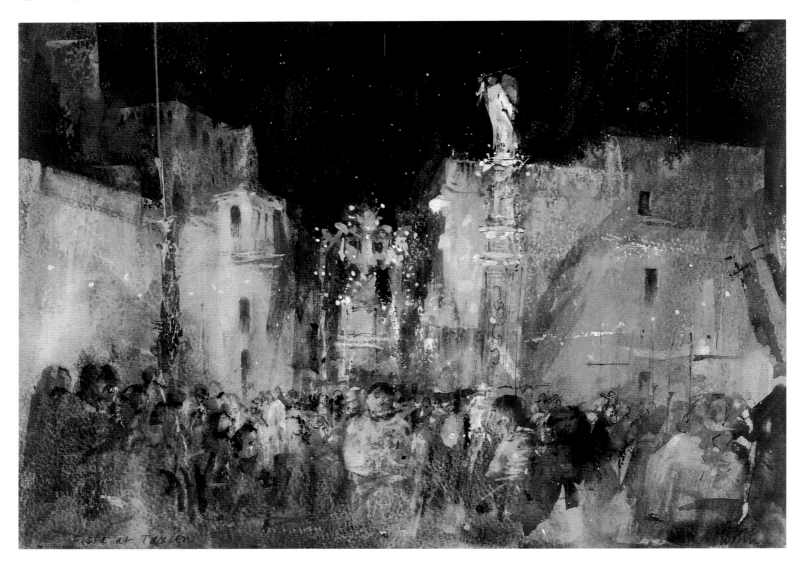

Festa at Tarxien (1992)
*Watercolour and bodycolour, 11 x 14 ¹/₂ in
(27.9 x 36.8cm)*
private collection

sents itself as subject matter. I don't really believe that great subjects make great art, or so-called good subjects make good paintings, but usually there is something that triggers off one's reaction.

It may be the way the light is behaving in the street, or it may be the movement of wind and weather, it may be people moving about within a fixed environment. Or it may be something cataclysmic happening, say a great thunderstorm over the town. Those things I think are simply one's own responses to forces which are outside of one's control, and to which one reacts; and the painting is the result of that reaction.

Leslie Worth's predilection for making himself available to depict images of local street life is apparent elsewhere. On a 1992 visit to Malta with members of the Royal Watercolour Society, Worth and his colleagues attended the Festa at the small town of Tarxien. Best known for its monolithic prehistoric temple, Tarxien was dressed up on that May night. Crowds milled along streets echoing to the strains of marching bands, and later resounding with the whoosh and crack of fireworks. The centrepiece and purpose of the evening was to parade giant illuminated wooden effigies of the saints through the town to the flower-bedecked church.

Worth has captured this scene in a number of energetic watercolours, one of which is reproduced here. Using a mixed palette of washed, smudged and rubbed watercolour, outline pen-work and sparky dabs of bodycolour against the inky black sky, he has revived some of the drama and vitality of the scene. A jumble of figures crowding towards us, followed by effigies raised high into the night, are surrounded by the ghostly façades of buildings washed by coloured light.

The handling is appropriately free to convey the fervent Mediterranean exuberance of the scene, much as the tight description of *Intergalactic Art* was suited to its American architectural subject. Like other works of recent years, *Festa at Tarxien* signals the total liberation of Worth's technique and mark-making from the requirements of his academic training. The needs of the subject, and the effect the artist wishes to achieve, have dictated the method of its depiction.

In September 1993 Worth was a delegate on a visit to China, organised by the American Citizen Ambassador Program and led by W.S. Blackshaw, Chairman of the Friends of the RWS. The purpose of the trip was to further international understanding and exchange in the world of watercolour. In Nanjing, some 250 miles inland from Shanghai, another example of local street activity attracted Worth to sketch and eventually record it in watercolour. He explains what is going on:

> What actually happened was that one evening, after a meal, I wandered into the back-streets behind the hotel in Nanjing, which were very crowded and full of street-traders

Children on a Trampoline, Nanjing
(1993)
*Watercolour and bodycolour, 14 ¹/₂ x 21 in
(36.8 x 53.3cm)*
private collection

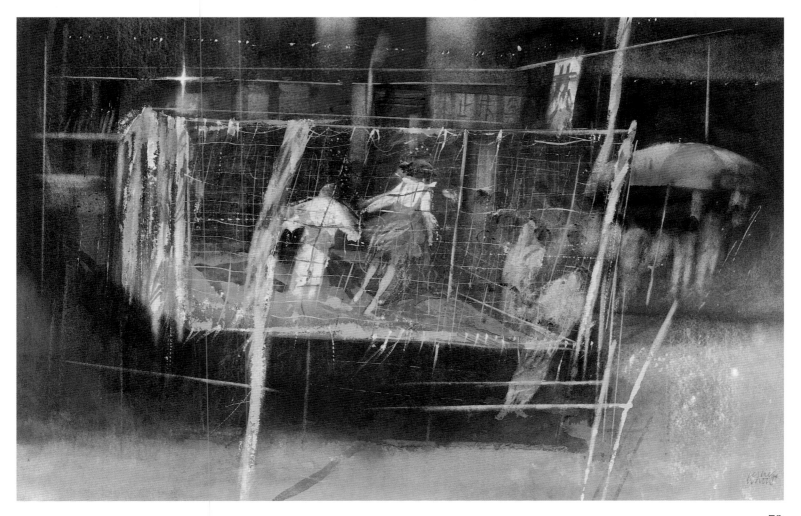

Children on a Trampoline in Nanjing
(1993)
Graphite pencil and pen, 8 x 11 3/8 in
(20.3 x 28.9cm)
private collection

and shops spilling out onto the pavement, and so on. I eventually wandered through this little labyrinth of streets into a tiny square at the back, where apparently there was some sort of amusement arcade. There was a fast food place there and a sort of club, and the whole place was thronging with couples and groups of boys and girls wandering about. And in the middle was this rather crude trampoline, set up on trestles, with netting spread round the sides so that if the children lost their balance, at least they wouldn't fall out onto the street. The whole thing was floodlit. It was very dramatic lighting. And I simply drew it in the sketchbook.

I previously discovered that using a sketchbook in China attracted enormous attention. So I was always careful afterwards to position myself so that nobody could get behind me, preferably in the corner of a wall, so that at least I could draw without people pressing at the back. But even so they came right up in little knots of people, bending over the sketchbook, looking at me and smiling broadly, saying 'Okay, Okay', and giving a thumbs up sign.

I simply drew these kids as they leaped up and down, and from which I did a painting. I took some photographs, but in actual fact I found that the sketch was much more informative than the photographs were. I somehow got the elements of movement in

the drawing, and it seemed to have the atmosphere, whereas the photograph would give me very precise information. I tried to suggest the bustle and the noise, the kids' shrieks and the shouts of passers-by. It was an animated thing. I didn't know at the time whether it was going to be a picture or not; I just drew it. It was only in retrospect that I thought there was some material there.

The sketchbook study is full of vitality and, by the standards of the rather carefully composed and finished Winnipeg drawing, undoubtedly carried out in a matter of minutes. Standing close up to the trampoline in the small square, the perspective of the netting 'cage' distorts progressively towards the right. The effect is preserved, although moderated, in the watercolour (page 79). Like the Tarxien Festa picture, this small painting is all about capturing the life and spirit of the moment, of encapsulating the sounds, movement and excitement of local street life in the flexible medium of watercolour. Tarxien succeeds in this, and the result is effective. The Chinese scene is equally effective, but it is also a quite beautiful painting.

Deep, soft washes, heavily rubbed and abraded, form the background: an evocative paraphrase of the Nanjing backstreets, highlighted by banners inscribed with Chinese characters, and a parasol. On top of this backcloth a framework is scraped out, within which the netting and trampoline, and the two bouncing children, are drawn in opaque bodycolour. Against the blurry dark brown and indigo background in watercolour, the contrasting blue and buff bodycolour offset with patches of white and red emphasises the oddity of the scene. The strange, simple image, like a chicken coop designed for fun, undoubtedly found the right artist.

This humble Nanjing scene contrasts with one observed in the Forbidden City in Beijing, over 500 miles to the north (pages 82–3). Probably overwhelmed by the grandiose proportions of the Imperial Palace, Worth has chosen an off-beat view of the building's vast, unadorned, paint-peeling wall. As in *Intergalactic Art*, he confronts the wall head on, but in this instance there are no architectural mouldings to entertain the eye, and the flat surface is relieved only by the painter's ability to transform its drab, earthy wastes into a rich feast of brushwork. The double-page illustration gives some idea of how brave, indeed confident, in this ability the artist must have been when he was 'chosen by' this subject. The sheer scale of the paper sheet might be thought to help his cause, allowing for an infinite variety of brush-marks. But equally one should bear in mind that Worth has demonstrated how he can convey a sense of monumentality on the smallest sheets of paper. As much as anything he perhaps delights in the pure challenge of animating the brushwork over a large area. The sheer labour of the task echoes that of repainting the very wall itself, but is worn lightly.

The wall repays close study. Firstly, it is not, of course, all one colour: there would appear to be umber, sienna, ochre and greens at least. Secondly, there are three strata of paint, perhaps repeating the process of decorating the wall. Thirdly, patches of watercolour and bodycolour are overlaid and juxtaposed, giving depth and textural variation, and representing the effect of raking sunlight. Fourthly, the marks are not random; nor are they regimented, but they have a consistent horizontal and vertical structure, the scaffolding upon which looser marks are applied. And so, gloriously free and comparatively painless as it might seem, there is nothing casual about the wall.

The quirkiness of the subject is enhanced by the positioning in front of the building of a local cleaner, standing to attention, brush in hand. One hopes, for her sake, that she is not employed to scrub the walls. In fact she was transplanted from a sketchbook study of another part of the Emperor's Palace, to provide scale and to demonstrate the massive height of the monumental stone plinth. To the left, two figures disappear into the gaping chasm of the interior.

On its large scale this composition can be read in non-representational terms. The four rectangles of wall, plinth, door and paving, the latter enlivened by receding lines, are the only principal shapes in the picture, and their exact disposition is vital to the balance of the design. Into

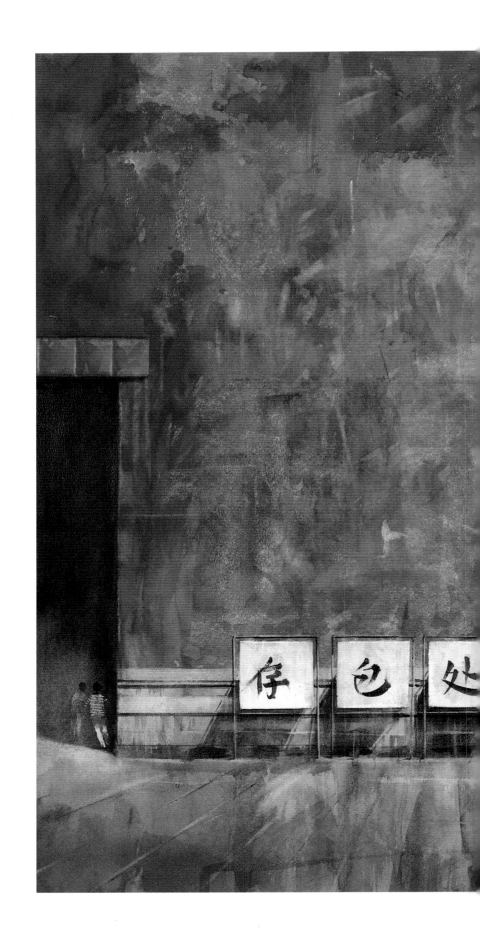

**The Great Red Wall, Imperial Palace,
Beijing** (1994)
Watercolour, 23 x 33 in (58.4 x 83.8cm)
private collection

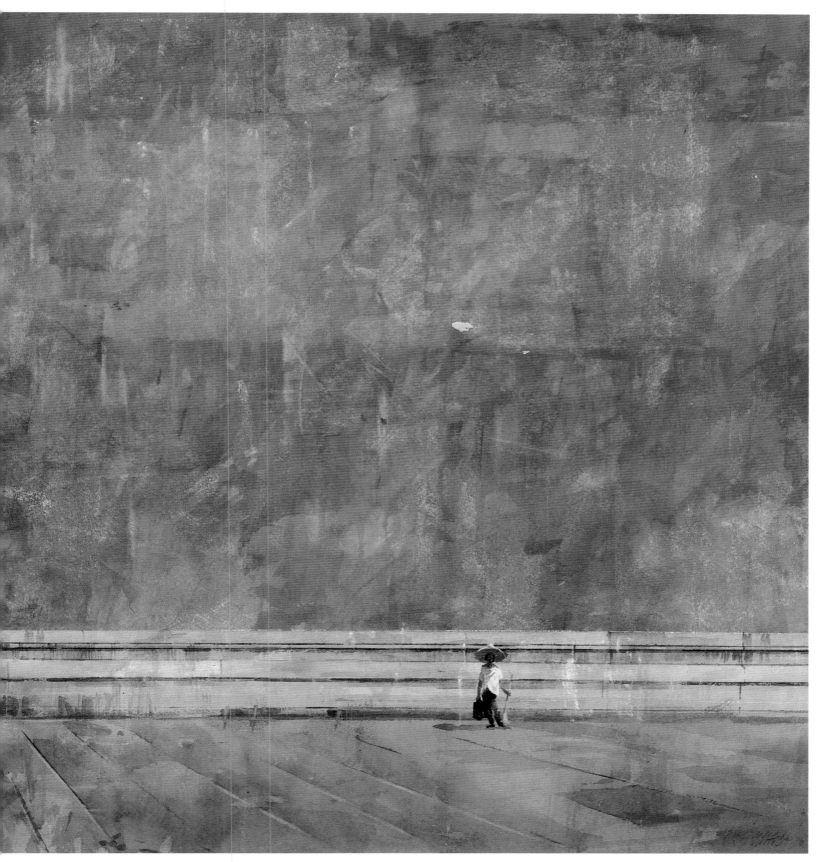

Li River, Guilin, with two Hills (1994)
Watercolour, 9 ³/₄ x 13 ³/₈ in (24.8 x 34cm)
private collection

this arrangement come the figures and the hub of the composition, the three finely painted white banners, their shadows cast against the plinth. These three squares provide the final and essential interest that turns an interesting concept into a successful composition and a work of art.

China's rural scenery also called Worth to take up his sketchbook. From a series of brief sketchbook studies made while on a boat trip on the Li River have resulted a number of exotic watercolours. The Li River in Guilin is one of the most revered tracts of China's landscape, both for the mythology that surrounds it and the extraordinary, sheer hills that dominate the waterscape. Two of these hills are seen as shadowy shapes to the left of one of the two works illustrated here. Worth describes how he reacted to such new experiences:

> The first reaction was one of astonishment. It's quite unique. It didn't remind me of anywhere else. I think my reaction was a mixture. I didn't know at first whether it was beautiful really, or just bizarre. In some ways I could look at it in a sort of apprehensive way. There was almost something grotesque and rather threatening about these beehive mountains hedged around, and I felt I was trapped in a rather unfriendly situation to begin with. As I got more adjusted to it, then I saw it as something else. And finally I thought it was really rather beautiful.
>
> I would say the initial reaction was one of astonishment. The first sight of it was coming off the plane at Guilin in the evening, on a sultry evening and very misty – it's a mist-laden landscape down there – and there beyond the tail of the aircraft were these extraordinary things, with the sun setting between them. It was a wonderful sight. And later, the next day, we went down the river, and we began to see them more at close quarters as the river was winding through them, and we saw that the banks are fringed with these fan-like bamboo canes that have been stripped of everything except the tops, like big mops. In these two watercolours it was the light, atmosphere and space I was really concerned with.

For the uninitiated observer both works capture perfectly an oriental light and atmosphere, the

sharp but pastel colouring conveying a vision of a strange exotic land, of swampy deltas and ancient river craft. They remind the artist of the watercolours of an earlier visitor to China, George Chinnery. The pure economy and beauty of this first encounter with the Chinese landscape might also bring to mind Turner's first experience of the Venetian light, while the method of mark-placing perhaps recalls Worth's interest in Japanese and Chinese brush painting. But no matter which precedent we might cite, they are sincere and original responses to new shapes and to a new light.

The striking, poetical image of the two bamboo canes isolated in the mist is reproduced here in detail as a colour frontispiece, and as a whole in monochrome below. This modest enough work is surely one of the most perfect and lyrical expressions of the contemporary water-colourist's art. Granular, wet-in-wet washes suggest the form of hills beside the river. On top of this, still on damp paper, the artist has indicated the immediate foliage of the river-banks. And looming out of the mist, against the light, are the two 'mops', painted on to drying paper. A solitary houseboat sits on the tranquil water. This detail appears to be suspended in the ethereal atmosphere, as if an analogy for the serene articulation of a Zen poem or proverb. Such magical painting is the stuff of legends. We shall be exploring this side of the artist's work in the next chapter.

The companion watercolour, also illustrated here in black and white, was likewise taken from studies made on the river cruise, and is more panoramic and complex in handling. A low watery sun shines with penetrative radiance over a broad stretch of water. A bamboo raft is moored to the left bank ahead, and beyond rise the precipitous blue hills referred to by the artist. With its bright hazy light, this is for all the world the kind of river scene from countless movies about the Far East. Again the washes are granular, with the apparently scant infusion of pigment separating from the water, and settling in the valleys of the sheet's 'Not' surface. Although some of the washes have flowed together on damp paper, particularly on the right bank of the river, the general effect is of precise coloured marks, breaking into the overall watery washes to state the specific elements of the design.

On a different continent, and on a much larger format, *Afternoon at Barron Falls,* Victoria, South

Li River, Guilin, with two Bamboo Canes (1994)
Watercolour, 9 ³/₄ x 13 ¹/₄ in (24.8 x 33.7cm)
private collection

Hot Afternoon at Barron Falls (1990)
Watercolour, 21 x 22 ³/₄ in (53.3 x 57.8cm)
private collection

Australia, is fired with an even more dazzling light. Worth shows how such brilliance can blank out tangible form, much as Turner did, to different effect, in a substantial amount of his work. Here the sunlight destroys any visible detail of the land at the top of the falls, as our eyes adjust to the shadow of the precipitous cliff faces. The geology of the subject is powerfully described by the contrast of light and shade, but the intense light has eliminated the sharp lines that we saw in the paintings of the cliffs of the English coast. And the blue, blue-green, light ochre and white

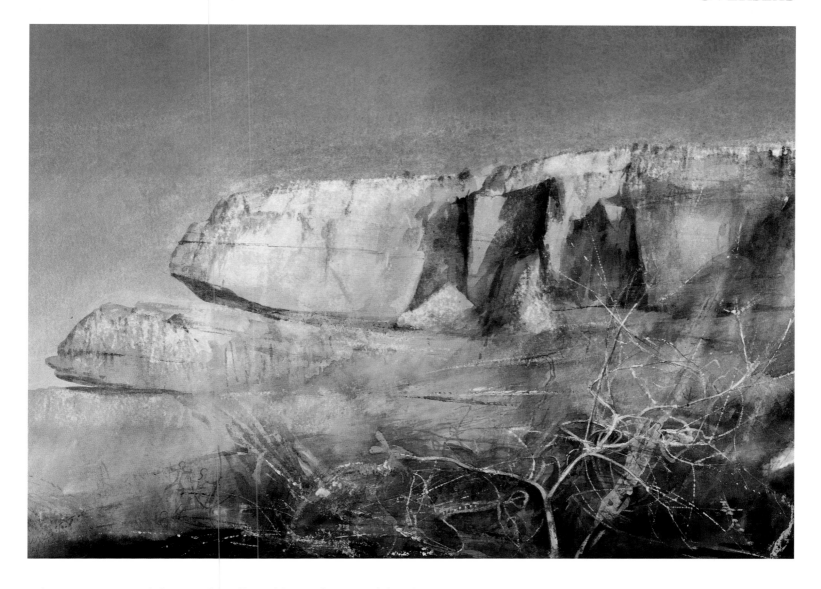

colouring is as un-English as are the yellows, blues and greens of the Chinese river views. As ever, Worth has adapted to his subject, its light, atmosphere and colour.

The brilliant southern sun also catches and defines *Rocks at Nourlangie,* in the Northern Territories, in a second Australian watercolour. The light is warmer though, and less destructive. The jutting rocks take on the look of crouching lizards, basking in the heat. One might almost expect a sharp tongue to dart out from the horizontal fissures to the left. And the artist makes his superb 'cliff-face technique' count on the rock surfaces, the dry brushwork convincingly rendering the dry and dusty stone.

On their 1990 trip 'down under' Leslie Worth and Jane Taylor stayed with Kenneth Jack, an Australian RWS member, for a time, and travelled to some other remote spots with him. This one they found for themselves. But here we see some of the characteristic Australian colours of red earth and deep blue sky familiar from Jack's paintings of the outback. To the front of the picture an entwined tangle of white branches is seen against a sienna backcloth. The twisting branches have been observed and then apparently redesigned to form a complex pattern that merges together with some native Australian rock drawings. To the left are two small figures,

Rocks at Nourlangie, Northern Territories, Australia (1990)
Watercolour, 14^1/$_2$ x 21 in (36.8 x 53.3cm)
private collection

Walking to the Boat on Minnewanka
(1984)
Watercolour, 8 ³/₄ x 13 ¹/₂ in (22.2 x 34.3cm)
private collection

outlined in sienna. In the centre foreground one can perhaps read a reclined skeletal figure and a prowling animal. The graphical, sgraffito-like marks on the paper provide a foil to the mass of the rock faces.

This chapter of travels concludes with a view of Alberta's Lake Minnewanka, in the Canadian Rockies, painted in 1984. Seen against the light, a line of tourists depart for a boat trip on the mountain-skirted lake. We are looking straight into the sun, which sparkles on the water and glints on some moored rowing boats. The wide open spaces and clear air are emphasised by the sharply observed, receding line of figures walking through the panoramic perspective. But, as ever, it is truly the artist's handling and transcription of light and space that give the place its particular presence, and its sense of openness.

This is a fairly routine tourist scene by a well-travelled painter, who takes his subjects as he finds them. In this chapter we have seen that Worth is an artist who lacks prejudice about what sort of subject matter he ought to be depicting, who allows unpretentious subjects to grab and hold him, and to yield their pictorial qualities through his inspired brush. It has been by no means a comprehensive survey of his travels, and certainly not a travelogue. Although Worth is a collector of observations of a world of subject matter, his overseas work is not, on the whole, tourist topography. He remains at all times an artist first, a recorder of places second.

6

Landscape and Legend

We have already established that Leslie Worth's approach to his subject matter is not exclusively naturalistic or topographical. Almost without exception his paintings hint at, or sometimes make explicit, some deeper interpretation of our world, and of the events which affect it. In general, however, it has been found either difficult or unhelpful to elaborate on or try to explain in words the meaning of this interpretation. Indeed the 'meaning' may be subliminal rather than overt, perhaps unknown to the conscious mind of the artist, and impossible to articulate. If we do struggle to find an apt, if inadequate, word to convey this quality, this appreciation of significance in the subject, it would be 'vision'. There is nothing unique in this quality: all the great painters have it, in some form or other. It is the 'X factor', that vital ingredient which makes Leslie Worth's painting of a cliff, of a river or of a building more than simply an efficiently executed, common-or-garden painting of a cliff, river or building. It stems not from technical ability, although a lifetime of technical experience is a more than useful vehicle for expressing the 'vision', but from an innate curiosity and empathy with one's surroundings, and a yearning to find and express more. And naturally enough these mental processes are modified as experience of life and art develops.

The watercolours collected in this section reflect Worth's vision of life and art, as do those elsewhere in this book. But what distinguishes this discursive assembly of work is that either implied or explicitly expressed in each is an identifiable level of meaning. This might be manifest in the colouring or atmosphere of a design, in which the artist has invested a mood or sensation. It might be a chance event, or an unexpected observation in nature, which provides a visual metaphor for a new or preconceived idea of the artist's. Or it might be a direct illustration to literature, invested in a landscape subject. What the paintings in this chapter reveal is the agility and restlessness of Leslie Worth's mind. Not an academic by training, indeed with little formal schooling, his is nevertheless an impressive and enquiring intellect. The wide range and oblique viewpoint on the subject matter in his *œuvre* confirm that he is rarely satisfied with repetition, or convention. When commissioned to undertake a routine topographical commission his boredom threshold is low, and he would rather search for a deeper significance in his subject matter.

Worth's interest in the arts reveals catholic tastes. In painting this enables his admiration of the early nineteenth century watercolourists to be enhanced and informed by an appreciation of, for example, American Abstract Expressionism and Colour Field Painting. A practising classical guitarist, as we have already noted, music is important to him. His literary interests span the writing of several cultures, and in this chapter we shall see watercolours illustrating works of American, English, Italian and Japanese literature, as well as the Old Testament.

The first watercolour illustrated is, however, at least one exception, or rather an introduction, to all that has been said above. To *Romantic Red Landscape* (page 90) can be ascribed no particular meaning, theme or literary reference. It is rather an experimental work, an exercise of the imagination, and one of a series of such watercolours Worth made in a spate of imaginative painting in the mid 1970s. At first glance this might appear as a completely abstract, even accidental composition. But one fairly quickly distinguishes what might be a stone building to the left of centre, and the branches of trees to the right of that. But the huge plume of red paint that

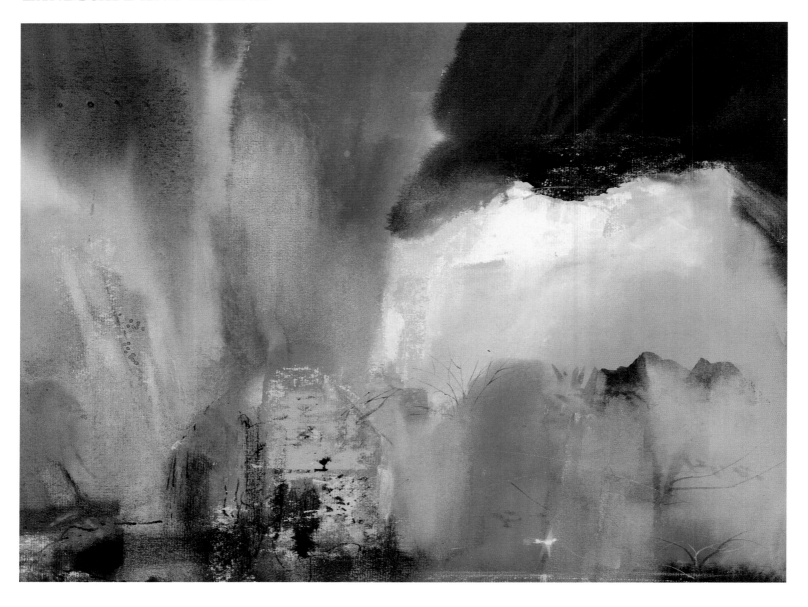

Romantic Red Landscape (c.1973)
Watercolour, 12 x 14 ¹/₂ in (30.5 x 36.8cm)
private collection

rises up from the building tells us, if we needed telling, that this is not a strictly representational painting. Worth explains how he arrived at the image, and at the title:

> It was an attempt to find a label for it actually, because it wasn't descriptive in the accepted sense, and it was largely playing about with imaginative elements: rock faces, or buildings, and cumulus clouds piling up, and shafts of colour which didn't have any geographical significance as such. It was largely playing with elements of picture making and finally arriving at some sort of statement, but not really setting out to describe something specific. It's very weak from a logic point of view. I think it only works, if it works at all, on the gestural impact and the interaction of colour and textural surfaces: that frothy cloud against the harder, rock-like surfaces and the steamy, lurid jets of colour against something which is rather ambiguous, I think, and rather enigmatic. It wasn't an attempt to describe anything specific. It was, in a way, just dealing with certain elements of painting, at the end of which I had to give it a label, so I called it

Romantic Red Landscape, because it looked more like a landscape than a still life, for instance. I wouldn't make any great claims for it.

A white dove flaps across the foreground, perhaps encouraging the viewer to read some sort of meaning into the painting. It may be more useful to suggest that this work shows the artist developing a language, with which he might find meaning in the landscape. As a Romantic landscape, in the sense of early nineteenth century Romanticism, its rich colours, its dramatic contrasts and movement are an expression of a profound feeling for the land and the elements, and a wish to convey this on paper.

The watercolour below, entitled *The Israelites*, tells a story about the power and drama of elemental forces, or rather the dramatic influence that divine intervention can bring to bear on them. Worth has taken one of the most visually exciting of Old Testament subjects as his inspiration. It is little surprise that an artist so often concerned in his work with the forces of nature should find the concept of the waves being parted a subject with some potential. The source is Exodus, chapter 14:

> 19 And the angel of God, which went before the camp of Israel, removed and went behind them; and the pillar of the cloud went from before their face, and stood behind them:
>
> 20 And it came between the camp of the Egyptians and the camp of Israel; and it was

The Israelites (c.1980)
Watercolour, 6 ³/₈ x 9 ³/₄ in (16.2 x 24.8cm)
private collection

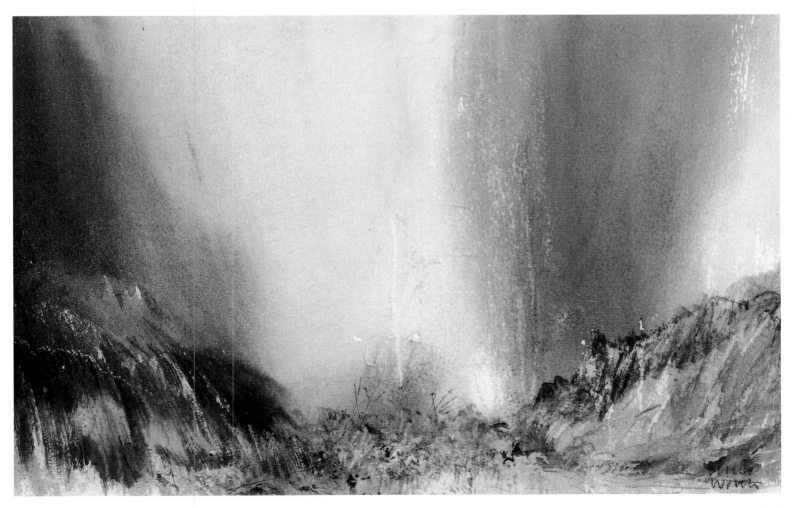

a cloud and darkness *to them*, but it gave little light by night *to these*: so that the one came not near the other all the night.

21 And Moses stretched out his hand over the sea; and the Lord caused the sea to go *back* by a strong east wind all that night, and made the sea dry *land*, and the waters were divided.

22 And the children of Israel went into the midst of the sea upon the dry *ground*: and the waters *were* a wall unto them on their right hand, and on their left.

The Lord then looked out through the pillar of light and the pillar of cloud to see the Egyptians in hot pursuit. After removing their chariot wheels, He went on to command Moses to close the waters behind him, thereby engulfing the Egyptians. Here, on a small sheet of paper, Worth invents a turbulent world of whooshing water and dazzling light, worthy of Turner. Deft strokes of a dry brush suggest human activity amid the elemental disturbance. The waters of the Red Sea have been brilliantly described, and although we might not be used to looking at receding walls of water, we can quite clearly recognise one to the left of the watercolour. Above, pillars of coloured light reminiscent of that seen in *Romantic Red Landscape* reinforce the evidence of Holy intervention, and the air of unreality in this powerful work of the imagination.

The next two watercolours illustrate subjects of Old Testament proportions and the drama is comparably high. Dating from about 1974, these are two works from a series of watercolours illustrating passages from Dante's *Inferno*, which were shown at one of the artist's frequent Agnew's exhibitions. *The Murderers* is taken from Canto XII, in which Dante, accompanied by Virgil, is led by Chiron, a centaur who is their expert guide. Chiron points out the murderers, who suffer in the gruesome river of blood:

> So on we move with our expert
> by the bank where the blood boils,
> and those boiling scream out.
> They were under to their eyebrows;

The Murderers, Dante's *Inferno*, Canto XII (c.1974)
Watercolour, 10 x 14 in (25.4 x 35.6cm)
private collection

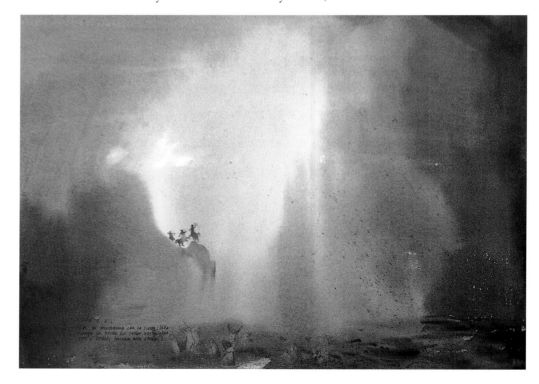

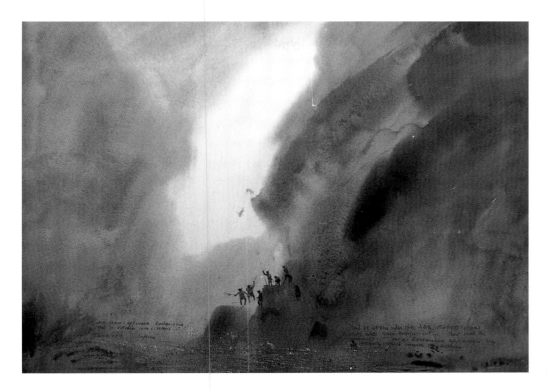

The Barrators, Dante's *Inferno*, **Canto XXII** (c.1974)
Watercolour, 10 x 14 in (25.4 x 35.6cm)
private collection

> the huge Centaur says, 'Tyrants,
> creatures of blood and pillage,
> lamenting here their heartless acts;
> here's Alexander, hard Dionysius too
> who gave Sicily its brutal years.

In the freely washed, blood-red watercolour, we see the three figures silhouetted above the seething river. In Canto XXII, Dante and Virgil come upon the river of pitch, in which struggle the Barrators, statesmen who sold their integrity. The inky blue-black washes of this second watercolour refer to the change of fluids. These are the lines from Dante's description that particularly interested Worth:

> My eyes were fixed on the pitch
> to study everything in this valley
> and the people being stewed here.
> Like dolphins arch out their backs
> and give a warning to sailors
> that they should save their boats,
> so occasionally, to ease the pain,
> a sinner's back would curve out
> then in again, quick as lightning.
> Or like at the edge of a ditch
> the frogs poke their noses out,
> keeping the rest of them hidden,
> so here the damned, everywhere;
> but when Barbariccia approached
> they go back under on the boil.

Barbariccia was one of the demons who one would not particularly want to encounter, despite having to withdraw one's nose back under the steaming tar. Worth captures in his illustration the vast spaces and putrid atmosphere that the tiny figures occupy. Most of all, however, he conveys in these two works the spirit, rather than the letter, of Dante's text.

From medieval Italy to Renaissance England. In April 1994 Worth participated in an exhibition in honour of Shakespeare's birthday. This show was held at the Royal Watercolour Society's Bankside Gallery, just along the river-bank from the site on which the Bard's Globe Theatre was being reconstructed, near its original site. By sad coincidence Sam Wanamaker, the inspiration of the reconstruction project, died shortly before the exhibition was staged. Worth's contribution to the show was a series of five exquisite watercolours, all presented in one specially cut mount, on the theme of *The Tempest*. Act I, Scene I of the play is set 'On a Ship at Sea. A tempestuous noise of Thunder and Lightning heard.' At the beginning of Scene II Miranda tells her father Prospero about the great storm that afflicted the ship which carried Alonso, King of Naples:

> If by your art, my dearest father, you have
> Put the wild waters in this roar, allay them.
> The sky, it seems, would pour down stinking pitch,
> But that the sea, mounting to the welkin's cheek,

The Ship in the Storm, *The Tempest*
(1994)
Watercolour, 6 x 6 in (15.2 x 15.2cm)
private collection

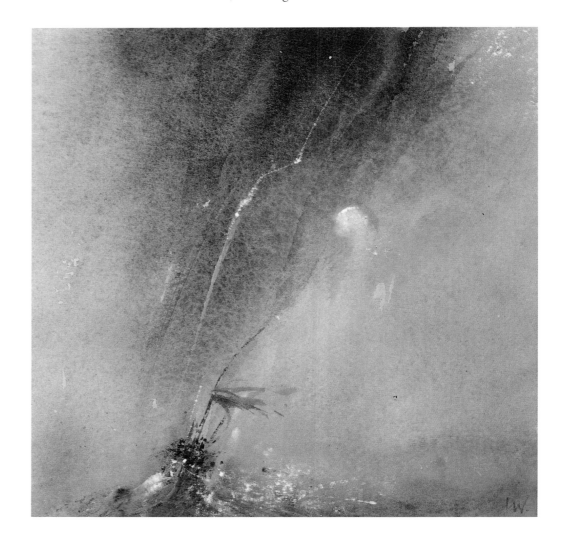

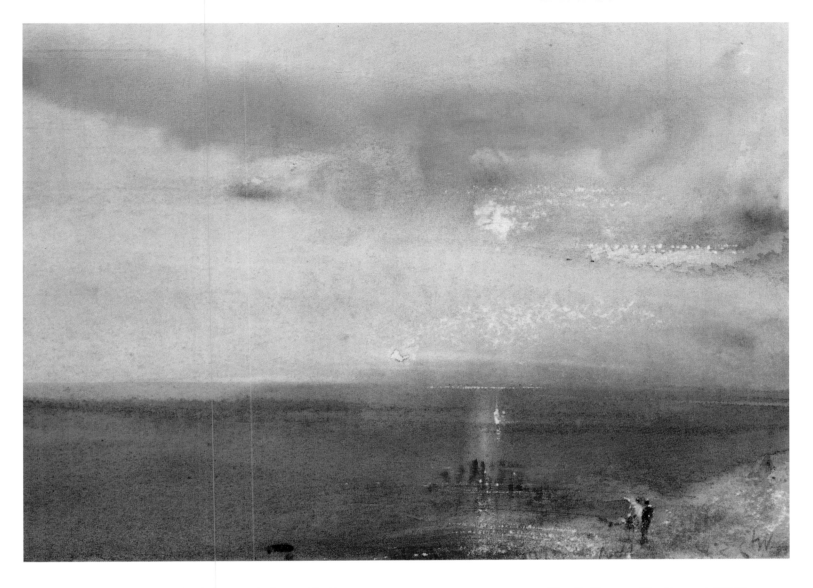

Dashes the fire out. O! I have suffer'd
With those that I saw suffer: a brave vessel,
Who had no doubt some noble creatures in her,
Dash'd all to pieces. O! the cry did knock
Against my very heart. Poor souls, they perish'd.

The Epilogue, *The Tempest* (1994)
Watercolour, 6³/₈ x 8³/₄ in (16.2 x 22.2cm)
private collection

Unknown to Miranda at this moment, the ship and all aboard were miraculously saved from damage, and the torn sail of Worth's watercolour is perhaps a reflection of her speech, rather than later knowledge. The tiny watercolour is a fine evocation of the storm. As with Worth's other miniatures, a distinctive grandeur of effect is achieved. The granular quality of the washes, proportionately of greater visual impact on such a small piece of paper, adds significantly to the sense of turbulence.

The second *Tempest* subject, illustrated here close to life size, is the last of the series. This view over a bay is an emblematic, rather than a literal, interpretation of the final resolution of the play, when, metaphorically speaking, the storm clouds have cleared and we move towards the Epilogue. The last words of Act V, Scene I are spoken by Prospero to Alonso:

95

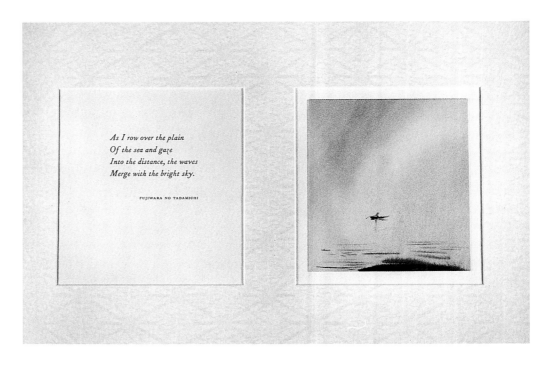

> *As I row over the plain*
> *Of the sea and gaze*
> *Into the distance, the waves*
> *Merge with the bright sky.*
>
> FUJIWARA NO TADAMICHI

As I Row Over the Plain (1974)
(Detail of mount)
Watercolour, 4 ⁷/₈ x 4 ¹/₃ in (12.4 x 11cm)
private collection

I'll deliver all;
And promise you calm seas, auspicious gales,
And sail so expeditious, that shall catch
Your royal fleet far off. – My Ariel, – chick, –
That is thy charge; then to the elements!
Be free, and fare thou well! – Please you, draw near.

And so they exeunt, before Prospero reads the Epilogue. Leslie Worth's visual embodiment of this passage is one of his most poetic small watercolours. In a few square inches he has opened out a serene and spacious world, in which an onlooker, Prospero perhaps, looks out towards the setting sun and a red sky, promising fair weather for the next morning. The handling is assured and the result is quite ravishing.

In 1974, Worth had illustrated a set of six Japanese poems from Kenneth Rexroth's translation of *One Hundred Poems from the Japanese*. The six miniature illustrations are metaphorical as much as literal, evoking the atmosphere of the poetry. They are mounted alongside a unique letterpress version of the poems in patterned Japan paper mounts, in a presentation box. We see here two of the poems, illustrated by spare, lyrical watercolours of a heron, and of a rowing boat on the sea. The influence of Japanese brush painting is obvious, and Worth hand brushed a Japanese text character opposite the title page.

Painted as a separate exercise, the moody and mysterious watercolour entitled *Japanese Poem* illustrates the following piece of verse by Fujiwara No Sadayori, which was also featured in the six Japanese poems presentation.

> As the mists rise in the dawn
> From Uji River, one by one,
> The stakes of the nets appear,
> Stretching far into the shallows.

Leslie Worth explains how he interpreted these lines:

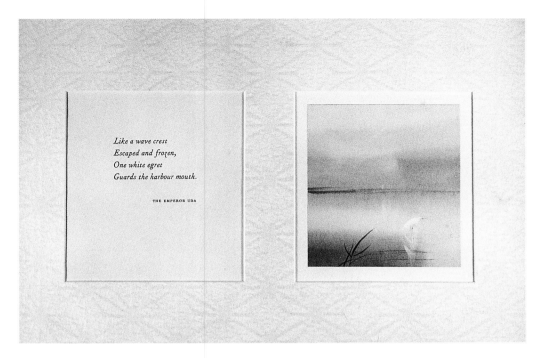

*Like a wave crest
Escaped and frozen,
One white egret
Guards the harbour mouth.*

THE EMPEROR UDA

Like a Wave Crest (1974)
(Detail of mount)
Watercolour, 4³/₄ x 4¹/₂ in (12.1 x 11.4cm)
private collection

The fishermen used to tie their nets to these stakes in the river, and early in the morning the mist used to obscure them. But as the mist lifted, so they gradually appeared. And so the whole idea of the painting was to try and convey this idea of something becoming, rather than a static image. It's an impossibility, of course, because you can't do it, but I tried to convey the idea that the sticks would appear more and more as the mist lifted. First you see one or two, then you see three or four, then you see five or six, then you see nine or ten, over a period of fifteen minutes, or something like that.

Japanese Poem (1974)
Watercolour, 10 x 14 in (25.4 x 35.6cm)
private collection

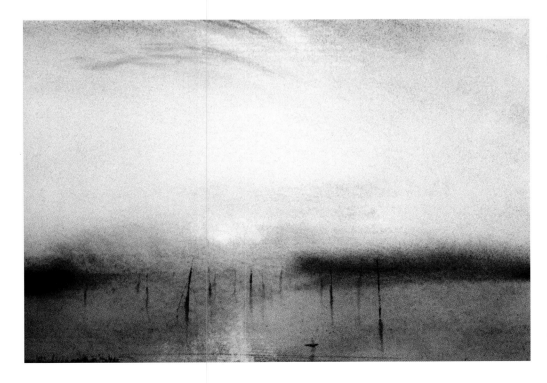

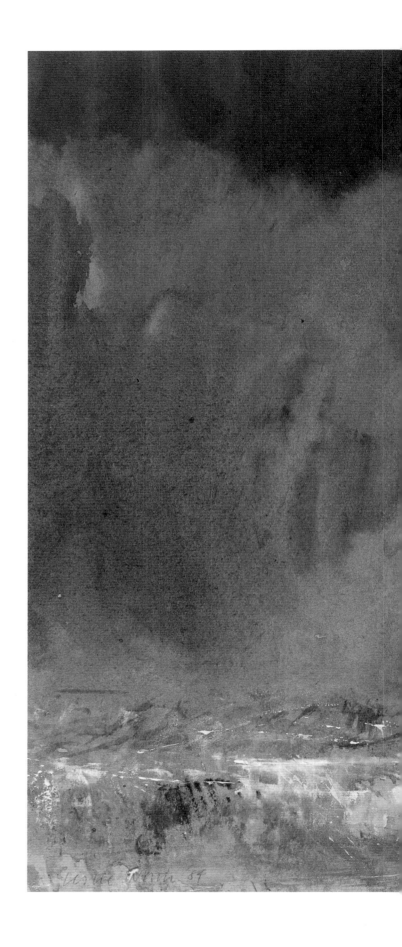

The Patroling Barngat (1984)
*Watercolour and bodycolour, 9 x 11 in
(22.9 x 27.9cm)
Tom Coates collection*

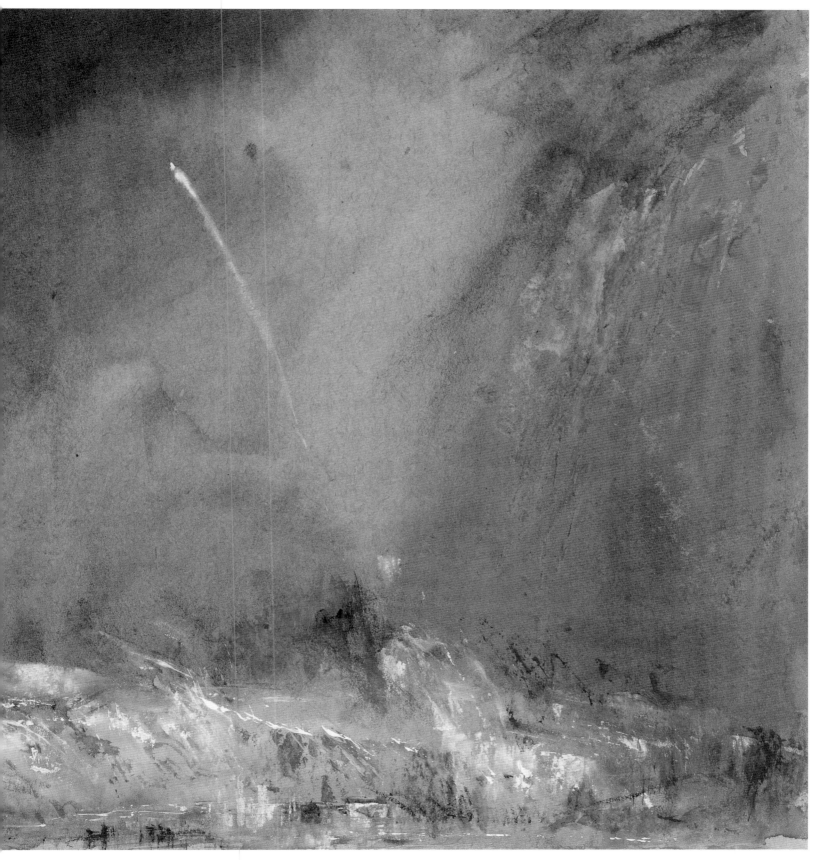

A lot of these Japanese poems have symbolic meaning, usually about unrequited love, or disappointment, or dawning hope, or whatever. Most of the imagery is conveyed as a vehicle for something else. I think it's wonderful really, and great economy. I don't know the originals, but in English they seem to be full of meaning. You can get a whole landscape, in just a few words.

The last directly illustrative watercolour in this chapter is *The Patroling Barngat*, reproduced on the previous spread very close to life size. The artist framed up the watercolour with a copy of Walt Whitman's stormy poem, from *Leaves of Grass*, within the mount:

Wild, with the storm, and the sea high running
Steady at the roar of the gale, with incessant undertone muttering,
Shouts of demoniac laughter, fitfully piercing and peeling,
Waves, air, midnight, the savagest trinity lashing,
Out in the shadows there, milk-white combs careering,
On beachy slush and sand spirts of snow fierce slanting,
Where through the murk the easterly death-wind breasting,
Through cutting swirl and spray, watchful and firm advancing,
(That in the distance! is that a wreck? is the red signal flaring?)
Swish and sand of the beach tireless till daylight wending,
Steadily, slowly, through hoarse roar never remitting,
Along the midnight edge, by those milk-white combs careering,
A group of dim, weird forms, struggling
The night confounding, that savage trinity warily watching.

Leslie Worth has conjured the terrible drama from an extremely limited palette of earth colours, together with some blue. Chinese white bodycolour is used to freeze the thundering, breaking waves, as well as the rocket shooting up from the barely visible ship into the leering, seething night sky. Every jagged brush-stroke, every disturbed wash seems to be imbued with the terrible tension of the event. Shortly after painting the watercolour in 1984, Worth was asked how he chose the subject matter and arrived at its visual transcription:

I borrowed from a library a cassette of readings of Walt Whitman's poems, by an American actor, and the whole thing came alive. So I went back again and read some more Walt Whitman. And I read this poem again, three years ago now, and the thing began to crystallise.

But, other things had happened in between, you see. In between reading them, of course, I had seen the storm at sea on the Dorset coast. You might say there was a fair backlog of experience, if you like. It's something which I decided quite quickly. I went back to the studio and worked on it, and it was probably all over within an hour. But that hour's work, of course, was only really the tip of the iceberg. There was the whole other backlog of experience, without which it wouldn't have been possible to achieve anything in the hour.

The Patroling Barngat is a majestic, Turnerian subject. It might be recalled that Turner was in the habit of displaying his major Royal Academy oils with appropriate verse appended in the catalogue. Many of his exhibited works, and those of his contemporaries and followers, illustrated fashionable poetry of the time. Indeed the exhibiting of paintings illustrative of literary subjects can be traced back to William Hogarth and beyond. It is a noble tradition in English art, espoused by Sir Joshua Reynolds, and quite distinct from the 'lesser' art of book illustration.

So far in this chapter we have looked at one imaginary, Romantic landscape, and a series of paintings in which Leslie Worth has applied a literary subject to a remembered or imaginary landscape scene. It is not a huge step from these illustrative or interpretative works, but a shift of emphasis certainly, to the apparition of metaphorical and literary subjects in the everyday, observed landscape. Two such visions in the artist's neighbourhood conclude this section. First, as stepping stones to these visions, are two less obviously illustrative works.

The effect of Far Eastern brush drawing on Worth's painting has been pointed out on a number of occasions. An elegant watercolour called *Celebration*, an acknowledgement of the wedding of Princess Anne in 1973, is one of the clearest instances of the artist's experiments with the expressive economy of Oriental mark making. The birds soaring into the blue yonder are metaphors for the painting's contemporary theme. Instead of illustrating an idea created by a third party, Worth has brought together his own image and an event that, once explained, is quite comprehensible to the viewer. And here, perhaps for the first time so intelligibly expressed, we can read the meaning of the intrinsic Worth image of a bird on the wing.

In *The Sea-gull* (page 102), the connotation of the bird is less clear. But, what is going on? At the height of a great storm, Worth watches from his studio window as his neighbourhood is violently blown about. The appropriately blustery handling and earth colouring define the mood of the piece. A girl skipping on the pavement makes an extravagant, balletic gesture, which echoes that of the gull. The bird is frozen in its wheeling flight, as if caught in the branches of a tree. *The Sea-gull* is a potent painting, redolent with oblique meaning. Worth observes an extreme natural phenomenon and associated events. His reaction is not to make a purely objective piece of visual reportage, but perhaps to comment on the vulnerability of flora and fauna in the face of elemental violence. And yet in the midst of all this, we have the strangely impressive gesture of defiance of the skipping girl.

Two ghostly figures seen against the light while out walking his dog in a local park one morning, a fleeting but obviously memorable experience, caused the artist to respond with a

Celebration (1973)
Watercolour, 10³/₈ x 14¹/₈ in (26.4 x 35.9cm)
private collection

The Sea-gull (1993)
*Watercolour and bodycolour, 14 ¹/₂ x 17 in
(36.8 x 43.2cm)*
private collection

beautiful watercolour entitled *Noli me Tangere*. A bird, superbly painted, flies across the dewy grass, and against the magical morning sun the bare branches of cherry trees entangle potently. As the title demonstrates, the artist's experience has led him to vest the landscape with a religious theme, to the extent that a story from John's Gospel is played out in twentieth century Epsom by the figures in the shadows before us. The incident depicted is when Mary Magdalene, seeking the body of Christ in the Sepulchre, comes upon a man she assumes to be the gardener. The risen Christ speaks her name and she immediately recognises Him. He then tells her 'Touch me not', *Noli me Tangere*. The Latin title might allude to its use for Italian Renaissance versions of the subject, in which Mary is traditionally depict-

ed kneeling in her attempt to touch Christ's garments. Worth has crystallised the Biblical 'reality' of the incident with appropriate trappings: the radiant early morning light, the gestural branches, the bird representing the Holy Spirit.

A comparable chance experience lies behind the last watercolour in this chapter, the unusual and very striking painting of *The Annunciation* (page 105), painted in 1984. In a backwater of the artist's neighbourhood in Epsom stands this charming late Victorian weather-boarded house. As we have seen from such uncompromising compositions as *Black Boat* (page 53) or *Intergalactic Art* (pages 74–5), it is not out of character for the artist to confront the subject head on. In this picture the whitewashed boarding becomes a second picture plane, a recessed second painting support, upon which a shadowed drama is enacted: a modern version of the Annunciation from Luke's Gospel. As in *Noli me Tangere* the subject is enhanced by the coincidence of natural phenomena, and here even the central protagonist, the angel Gabriel, is an accident of light and shade. An obvious precedent for this motif in the artist's work is the image of *Boy and Bicycle*, cast against another weather-boarded building in a painting of some thirty-five years before, illustrated on page 17.

One cannot pass by such memorable images as this and *Noli me Tangere* without asking some fundamental questions. Did the artist first have the idea for the subject, say of *The Annunciation*, which he then attached to an appropriate vehicle, or was there an instant of recognition, a sudden realisation when he saw the suggestive shadows, or did he simply observe and record a

Noli me Tangere (c.1972)
Watercolour, 13 ¹/₂ x 16 in (34.3 x 40.6cm)
private collection

visual moment which, later in a period of tranquillity and recollection, was fixed in paint?

Let's start at the beginning with a simpler question. Does Worth come across such events and images as he walks around the neighbourhood?

Well yes I do. The subject came later. Sometimes an idea comes at the beginning of a work, sometimes it comes at the end and sometimes it doesn't come at all. In this case what interested me first of all was the singular shape of the house: this sort of pyramidal shape that is off-centre, as it were, with an unequal length on the gable of the house, and a very decorative carved barge-board that runs around the perimeter of the gable of the house. And it is something about its frontality. And seen as a white building surrounded by a dark sky, it was extremely arresting as a shape. It had a purely abstract sort of quality about it, of this shape seen within a rectangular shape, which I felt was in some ways a very evocative image.

It was later, I suppose, in watching it on several occasions and taking photographs of it, that I noticed, as the sun declined, that it threw shadows on this large white surface, shadows of the cypress tree on the other side of the road for example, and the chimney pot that somehow detached itself from the roof and became briefly imprinted on the surface of the house.

The idea of *The Annunciation* grew out of other associations; this curious anthropomorphic shadow of the tree which was very singular; the woman that passed into the pathway that led to the house next door. Bit by bit the thing pieced itself together. I had this idea that the figure representing Mary as a woman comes out of the building to put the milk bottles out or something like that, and sees something that she is arrested by, but is not quite sure what she saw. If you look at the picture, she is shielding her eyes from the sun, with her forearm across her head, and she doesn't see very clearly whatever it is. And there is a curious shape where the sun, which is low, flings the cypress tree onto the wall of the building and makes an odd hump sort of shape, like a winged figure. And it is a short step from there to the extended arm in shadow on the wall.

I remember once being there and a pigeon flew past, and for a brief second the shadow of the pigeon was printed on this white surface of the building. It happened in a split second, but it was enough just to give me the idea that it was worth locking it up in my memory somewhere, that there might be a use for it. And of course it later took on the association of the dove as a messenger of peace and all that implies.

Is this a deep-felt pantheism, or is Worth a more conventional believer?

I'm not a conventional believer. I'm not a conventional unbeliever either, I don't think. It is very difficult to know exactly what one is with any degree of certainty. My own religious upbringing, which was a conventional and fairly strict one, has always exposed me to ideas of a philosophical nature, which interest me a lot. Reading into Taoism and Zen Buddhism and Christian apologists and Muslim writers has given me I suppose a ground base of certain conceptions which probably wouldn't stand too much philosophical questioning, but nevertheless support me and reaffirm certain perceptions that I might have about the way in which one looks at things, and the way one responds to ideas.

I'm very interested in the ideas that come in an involuntary way. Being open to chance encounter seems to me to be extremely fruitful. I like life that is seen out of the corner of one's eye as it were rather than the frontal attack. *The Annunciation* painting is a series of ideas which came to me rather obliquely. I rather like that. I rather cherish

that. Other people have a more cut and dried approach to life and no doubt find this devious. I find it subtle and more profound. The fact that I don't know is to me extremely interesting. I prefer it to saying that I do know, on balance. I find people who are very assured in their view of things rather disconcerting and on the whole rather unconvincing.

The Annunciation (1984)
Watercolour, 15 x 18 in (38.1 x 45.7cm)
private collection

7

THE FOUND OBJECT

The boxed constructions that Leslie Worth has made since the early 1980s have been an occasional and experimental diversion from his work in two dimensions. They might be put in context as an extension of what he has been trying to achieve in some of the paintings in the previous chapter. In the superficial resemblance between *The Annunciation* and an assemblage on white painted planks called *Radio Three* (page 108) we can begin to trace the relationship. The combination of observed or imagined human and natural events and phenomena that provide the

Bird and Sun and Rock (c.1980)

Painted wood construction, 16 x 13 in (40.6 x 33cm) including box frame private collection

Money Guardian (1993–4)
*Painted paper collage, 15⅝ x 19⅝ in
(39.7 x 49.9cm) including frame
private collection*

theme for that painting were collected and combined on the backcloth of the weather-boarded house. Some of the other pictures in that chapter have been constructed in a similar, if less obvious way.

The assemblages illustrated here are the product of a related process. Worth has incorporated some intriguing and provocative combinations of assorted objects within elaborate frames. In *Bird and Sun and Rock*, we see the archetypal *objets trouvés* of the Surrealists, of Paul Nash and Henry Moore: the found object that nature or the elements have shaped into some other interesting naturalistic or abstract shape. The beach is a classic hunting ground for the *objet trouvé*, and provided the three pieces of driftwood that Worth has applied here to a painted and sanded wooden support.

While this evocative relief captures the spirit of the St Ives artists, Ben Nicholson and Barbara Hepworth, *Money Guardian*, like many a modern painted *papier collé*, is redolent of Picasso and

Radio Three (c.1980–1)

Painted wood construction with paper
collage, 20 ¹/₂ x 22 in (52.1 x 55.9cm)
including box frame
private collection

Cubism. It also recalls the Dadaist, Kurt Schwitters, who was fond of incorporating an intriguing range of rubbish, from bus tickets to old shoes, in his experimental collages. As a refugee, Schwitters was coincidentally working at Ambleside when Worth was attending the Royal College there. Worth's respectful title refers to the financial section of a British national newspaper – part of the masthead being included in the work. The seemingly random assemblage of patterned and printed paper scraps is enhanced with paint and gold paper which, with the finely crafted frame, creates an appropriately rich and tactile effect.

Radio Three is named after the BBC classical music station that is referred to on a printed cutting in this last of the illustrated assemblages. Again found objects are applied to a painted surface, this time in a rhythmic arrangement which is perhaps an expression of the theme of the work. There is a conscious interplay between the two and three dimensional elements. There is the suggestion for example that, Jasper Johns-like, one of the curved pieces of wood might have been employed to trace the brown-painted quarter-circle. The interplay and movement of shapes is played off against the static, white painted planks within a box-like frame. As in *The Annunciation* the principal elements of the work are frozen on horizontal white boards.

How does Worth decide upon the theme and choice of objects in these assemblages?

> I think in a way the title comes at the end and is simply chosen to give some sort of identity to the object. Basically they were just fun things really, nothing more serious than that, and a bit of relief I think from the rather cerebral activity of watercolour. Watercolour isn't very physical and I've always been interested in using my hands. My grandfathers were craftsmen with their fingers. One was a tailor who could cut cloth in the right shapes; the other was a carpenter who built gates and fences, cabinets and things like that – a country carpenter. I've always been interested in wood-working and in the construction of musical instruments. I've built a couple of guitars, which didn't work really. To the layman they looked as if they were all right, but as a musical instrument it was more of a carpentry job. But guitars interest me because of their construction, which is allied to the sound. This sort of construction will give you that sort of sound and there's always a mysterious element.
>
> So, in a way, playing with bits of wood and bits of metal that I've picked up was just having a bit of fun with something physical, trying to put it together in a way which had a meaning, either of association, like the bird over the sea – but accidentally it looked like a bird and accidentally it looked like the sea because that was the way the paint peeled off the piece of wood that I had – or it simply had a certain relevance of colour, like the gold paper in *Money Guardian*, or *Radio Three*, in which the elements were chosen because I thought this looked good against that, that's all. I think things like interval and correspondence come into it. If I put this down parallel with that, it's less interesting than if I put it at an angle and there's a tangent set up between the two. Unless that's meaningful to somebody else who looks at it, they'll say they're just not parallel, what are you going on about? I don't want to suggest there's any mystique about it!
>
> I think if there is a meaning at all in the assemblages, it's largely a concern with the interrelationship of the elements, which is either of elements that are similar to one another or in contrast to one another. For example, a patch of sandpaper against a patch of sandpaper is less interesting than a patch of sandpaper against a smooth surface, because you've got the interaction of one surface with another.
>
> Similarly, interval is something to do with it. One dark area and another area have a certain relationship against one another within a certain format. If you bring them too close together it's diminished, if they're too far apart it's diminished. Somewhere between near and far you feel intuitively that it looks about right. Then what I do usually is to drop bits down onto the board and I'll move them around until I think, yes, that's got a feeling that's right. Sometimes it's disastrous and only finally does it come together. Sometimes it doesn't come together at all and I'll throw it away. Sometimes it just looks a bit kitsch. I wouldn't make any high claim for it. Most of the time I did it as a form of relaxation really, as a change from watercolour.

Although made for his own interest, as an extension of and a welcome diversion from his more usual occupations, Worth's assemblages are surprisingly complete works of art. It is worth

Turnip (c.1990)
Oil on board, 9 x 10 ¹/₂ in (22.9 x 26.7cm)
Tom Coates collection

noting that, like Michael Rothenstein before him, Worth was privately making art in boxes long before the craze for the medium that developed in the late 1980s.

As we have seen, Worth turned from oil to watercolour as his principal medium at an early stage. Yet as well as works in other mediums, such as the assemblages, and the murals we shall see shortly, he still from time to time makes a few small oil paintings. And, as if relishing the change from the subtle complications of the flatter medium, the little oil on panel of a *Turnip* exploits the sculptural potential of the medium as much as *Money Guardian* drew out the rich contrasts of paper textures and patterns, or *Bird and Sun and Rock* explored the physicality of driftwood. But an artist of Worth's integrity will always use the materials that are for him likely to prove the most appropriate vehicle for the effects and ideas he wishes to express.

In this intense study, the plastic richness of oil paint is very suited to the gnarled and lined surface of the tough-looking turnip, with its accompanying, rather ineffectual knife. Worth has relished this quality of the opaque medium, and manipulated it in a semi-sculptural way, physically echoing the texture as well as the colour of the turnip. It is modelled by a soft light coming in from the left which accentuates its mass. The intensity of this central motif is heightened by

the deep blue-black background. Worth's oil-painting technique does not look too rusty, despite its infrequency of use. The paint has been applied with both the brush and palette knife. For example, the plummy-black background has been brushed in, and then over this the horizontal surface has been suggested with slabs of blue paint, laid on with the knife. As well as implying a change of angle, this flatly applied paint catches the light and provides a variation of texture within these close-toned areas.

Still-life painting is a minor, but consistent subject theme in Leslie Worth's art. It would be untypical of the artist to set up, in traditional manner, an elaborate confection of paintable objects. Often only one object, whether a vegetable, a flower, or a crustacean, sits isolated against a simple background, enduring the intense examination and withering stare of the painter. The subject does not often get away with looking decorative. It is, metaphorically speaking, dissected, its structure analysed, and then reassembled for description. The turnip may physically have held its own, but the lobster illustrated here certainly didn't stand a chance.

Weathered flotsam apparently isn't all that Worth has found useful to his work while walking along the beach. The lobster will more accurately have come from the fishmonger, but a few shells are thrown in for good measure in the finished still-life painting. A closely related watercolour study is also shown overleaf. This is the most obvious example in this book of two watercolours, as opposed to a sketchbook study and a finished painting, that have such a close

Lobster and Shells (1991)
Watercolour, 14 x 20 in (35.6 x 50.8cm)
private collection

Study of a Lobster (1991)
Watercolour, 11 x 15 ⁷/₈ in (27.9 x 40.3cm)
private collection

relationship. Not an everyday object for most of us, the lobster would have required close study. With presumably limited time at his disposal, it was clearly important for Worth to establish its colours and articulation in watercolour, rather than a monochrome medium. In this black and white illustration we can appreciate the tonal record provided by the study. What has resulted is a watercolour sketch fit to exhibit, and one which provided the necessary information for further use, as transpired in the larger painting of *Lobster and Shells*. Substituted for the raw washes and blobs of the smaller study is the more modulated brushwork of a finished watercolour. The introduction of the shells provides a more conventional, almost anecdotal, still-life look, and the pink against the blue makes for a striking colour scheme.

What each work in this short chapter has in common is the isolation of objects, found or otherwise acquired, within a physical or pictorial space. Without exception the object is thus invested with a presence, sometimes even a suggestion of meaning which, in other circumstances or in the hands of a lesser artist, its physical stature or shape would not warrant. Just as Leslie Worth can find subject matter in unprepossessing quarters of New York, so he can ennoble a humble piece of driftwood, or a root vegetable.

8

FAUNA AND FRESCO

The ability to instil significance and interest, and perhaps beauty, in simple subject matter is a by-product of an artist's examination and portrayal of the world around him. Leslie Worth's success with unpretentious still life translates well to careful studies of live animals, providing they stand still for long enough. In this chapter we will see several studies of fauna, both in their natural environment and in major pictorial compositions. These latter works are among a small series of commissions for murals that Worth has undertaken since the early 1960s.

The large format of these murals and the wax- and acrylic-based paints that the artist has used for the purpose lend themselves to clear and distinctive designs, full of interest and activity. In the works shown here Worth has designed grand, symbolic landscape schemes, which he has populated with figures and animals. The subjects are pertinent to the patrons and the buildings for which they were commissioned. But from the first mural, painted for Ilkeston College of Technology, Derbyshire in 1961, to that created for The Holme, Regents Park from 1984 to 1986, the stylistic approach to the commissions have been consistent.

All these works, particularly the Ilkeston mural, are reminiscent of the tight, stagy street scenes painted by the artist around 1950. But there is also a distinguished precedent for these works: the great heritage of North Italian fresco painting, from Masaccio to Raphael. Fresco technique demands that clearly defined areas of wet plaster are painted to a finish before they dry. These areas therefore have to be shaped according to the overall design of the work, and the inherent linear qualities, particularly of Florentine painting, are thereby accentuated.

The Artist working on the Ilkeston Mural (1961)

Mural for Ilkeston College of Technology (1961) *Oil and wax on panel. Four panels, 120 x 60 in (304.8 x152.4cm) each Ilkeston College of Technology*

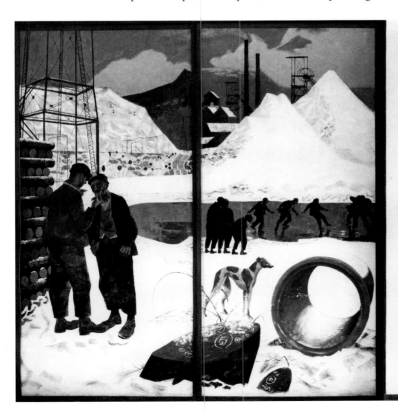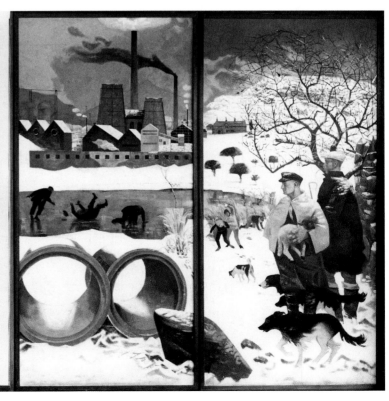

Worth's murals are not frescos, but they retain the clarity of definition established by the practice of that medium, which aids viewing at a distance. They also incorporate the traditional compositions, with foreground near life-size figures and animals, and landscape and architectural features receding to a suitable vanishing point. And some of the fauna that are represented have the heraldic quality of their antecedents in Florentine frescos. The whippet in the Ilkeston mural might have stepped out of a Mantegna or a Botticelli, the gently heroic pose of the man holding the lamb might also be seen in some Quattrocento fresco. The spirit of such painters has inspired

Calf at Zennor (1990)
Watercolour, 10 x 13 ¹/₂ in (25.4 x 34.3cm)
private collection

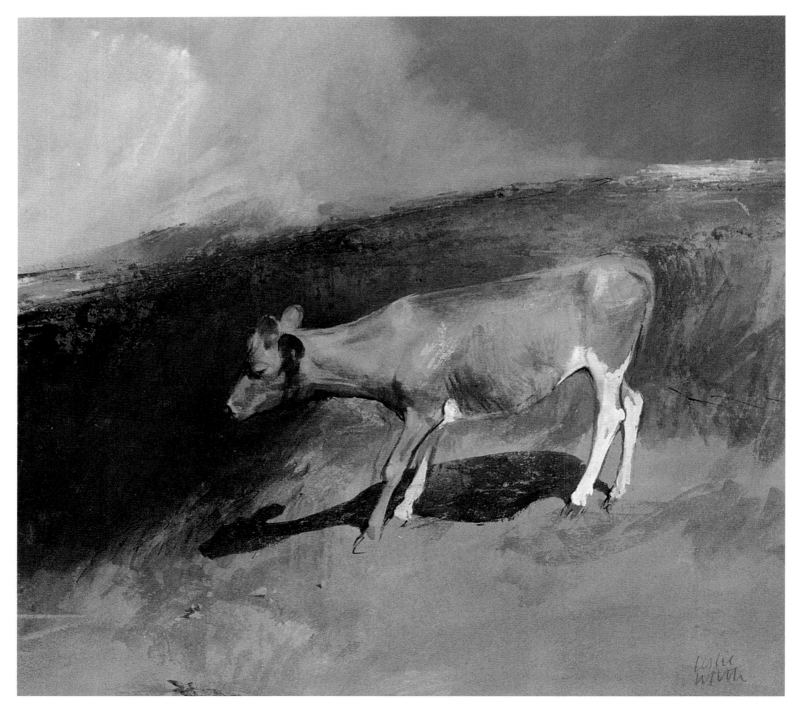

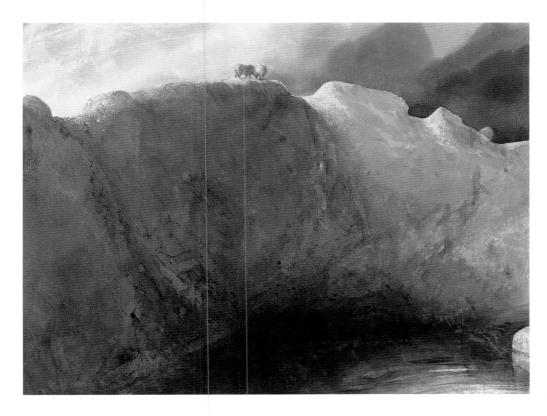

Flooded Pit, Derbyshire (c.1981–2)
Watercolour, 17¹/₂ x 21 in (44.5 x 53.3cm)
private collection

The Weybridge Mural (1982–3)
(Detail)
Acrylic
private collection

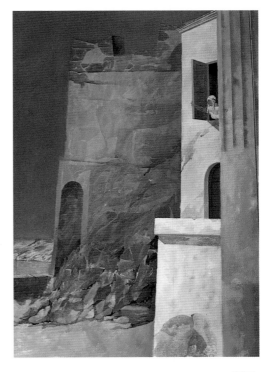

Worth to create a personal and inventive image of the industrial English East Midlands in mid-winter.

The four framed canvas panels, measuring ten by twenty feet (3 x 6m), and separated in the middle by a single column, were commissioned for a new building by the architect, the late Frank Rutter. As can be seen in the photograph, Worth worked on the panels as one continuous surface, before separating them for framing. The two near life-size groupings on either side of the mural help frame the work and provide the repoussoirs that lead the eye into the middle distance. The three pipe sections, almost certainly manufactured locally at the Stanton works, define the linear perspective and throw the skaters backwards in space. The technique of aerial perspective so often used in Worth's watercolours would be less appropriate in the more linear and clearly defined methods of mural painting. The medium used is oil colour mixed with the buttery medium of beeswax. This was chosen for its matt surface which would reduce reflections over the large surface area.

There follow two watercolours that depict animals. Neither could be precisely described as animal studies: certainly not the dramatic *Flooded Pit, Derbyshire*. In the beautiful little watercolour of a *Calf at Zennor, Cornwall*, Worth has studied the character and anatomy of the uncertain calf, but as the central subject of a sharply lit landscape scene. It is the darkened area of the hillside receding down to the left that has apparently startled the calf, which seems to recoil slightly. Although there is depth to the picture space, the animal is seen side-on, as if in bas-relief, momentarily caught in a patch of sunlight. A bright ochre and the intense blue of the sky are the picture's predominant colours, as they are in the companion watercolour. The weather on both days was clearly of dark storm clouds intersected by brilliant sunshine.

The intense light striking the side of the *Flooded Pit* creates a dazzling and sharply defined contrast with the indigo of the storm clouds. The interlocking planes of flat colour, as well as the subject, are reminiscent of the work of Cotman, an artist Worth particularly admires. A raking light, entering the picture space from the left, strikes the precipitous banks that surround the

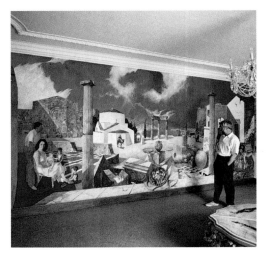

The Artist with the Weybridge Mural
(c.1983)
Photograph by Michael Giles

pit. Sheep graze up above, oblivious to their precarious position. The smoothness of the steep banks that plunge down into the gloomy depths of the flooded pit is relieved by layers of wash and broken brushwork, offset with scratching out. The frieze-like quality of *Calf at Zennor* is echoed in the shallow pictorial space of this watercolour. The pictorial drama of the scene is inherent in the vertical transition from sky to pit. In their quiet way the sheep provide the scale and perspective required for us to read the subject. As studies of domesticated animals in a landscape context, these two watercolours supply an oblique, but visually comprehensible, link between the still lifes of the previous chapter and the mural paintings.

In 1982, some two decades after the Ilkeston commission, Worth accepted an invitation to paint a mural for the drawing-room of a house in Weybridge. The wall to be covered measured nine feet (2.7m) high by some twenty-three feet (7m) long. It was decided that the mural would be an evocation of the commissioning family's native Greece. Opposite a set of french doors, giving a view over a delightful patch of semi-rural Surrey, Worth has created a parallel vision of an ideal Greek scene, dominated by evidence of that country's great classical past. The structure of the landscape mirrors that of the real pastoral vista, but beyond this Worth has given full flight to his imagination. The family pose to the left of the scene, the baby added as it came along during the course of the mural's preparation. The deep pictorial space, filled with activity, is keyed into a carefully defined linear perspective. These devices are redolent of the design of the Ilkeston panels. And the precedent of Quattrocento fresco design must have been as powerful an inspiration as before, especially with all this classical architectural detail around.

The mural might be considered even more successful in its many lively details than as the sum of its parts. For example, a superbly observed lizard pauses next to some equally sinuous, carved stonework. In another detail, a woman leans out of a tower window, in a romantic vignette that some Renaissance master, or a more recent Italian painter, de Chirico, might have conceived.

In 1984 Leslie Worth was asked by the interior designer Michael Giles to create a scheme of murals for The Holme, one of the great residences built by the young Decimus Burton as additions to John Nash's design for Regent's Park. Worth takes up the story:

> I had already done *The Weybridge Mural*, so it wasn't entirely leaping into the unknown. Michael Giles was one of a number of designers invited to submit a scheme for the decoration following the extensive refurbishment of The Holme, which was carried out for the Emirate of Kuwait, leasing it from the Crown for a limited period. It involved huge reconstruction and my particular involvement was in the scheme of decoration designed for the Bow Room, which was one of the two large reception rooms which faced out on to the lake in Regent's Park, looking out towards the mosque at St John's Wood.
>
> When I was invited to put up a proposal I thought there were two factors which governed the approach to be made in a scheme of decoration. In the first instance the age of the building: I thought whatever went into it ought to be instinctively of the period, which I saw as English chinoiserie. And secondly one could use elements of the habitat around The Holme – the wildlife, the plant-life, the zoo up the road and so on – and incorporate them as the ingredients of the design. Artistically and historically it would be appropriate, and from the point of view of the subject matter it would look as if it belonged there and not anywhere else.
>
> So that was the initial idea. From that I was invited to prepare a small decorative panel, of no more than a foot by eighteen inches [30 x 40cm], and give some indication of what the final treatment might look like. So I did a painting of a white pheasant and Michael Giles submitted that, together with his proposal for the scheme of decoration, to the client. And after due consideration it was accepted.
>
> The big problem from my point of view was that at no point could I enter the room

for which I had to carry out the scheme because it was undergoing such drastic reconstruction. So everything had to be done at one remove, simply by the use of architects' drawings. One of the first problems that was apparent to me was that I didn't know how big things were. So I built a model in cardboard to the architect's scale and painted it with the scheme of decoration. I made little cut-out figures and stood them up to get some idea of how big a bird would be on the wall compared to a man who was standing by the mantelpiece. Until I did that I didn't know how big these birds were. When I first of all started doing them they were too small, then I redid them and they were too big. Finally I got them down to what I thought was a manageable size: it's a bit much when you've got a swan so huge that it would frighten the children!

From there, having got the scheme accepted, a contract was drawn up with all sorts of dire clauses in it if I failed to produce the work by a given time, which frightened the life out of me. I used a two-year chart, pinned on the wall, on which I wrote: at this date drawings, colour sketches by here, canvas prepared by here and so on, and I'd keep to that timetable as I went through.

I had to do all the work in this studio, which is considerably smaller than the Bow Room. I did big drawings, first of all, on paper which was stretched from the ceiling down to the floor, and drew life size the designs that were going on the various panels, so at least I could see how big the dimensions really were. And then a firm of joiners constructed the twenty-five stretchers that were to go on the wall, the largest of which were nine feet [2.7m] high by five feet [1.5m] wide. Then a firm of upholsterers came in and stretched the cotton duck canvas onto the stretchers. Then I primed them, and then I wanted to give them a base colour. We were working on a basic ivory-peachy ground, and the designs were vignetted, so that they weren't solid from edge to edge, to give a light feeling within the room.

I had a terrible job trying to mix up the colour for all these canvases. I could do three, but when I got on to the fourth I found I was changing the colour. Every time I mixed up some paint it veered a bit. Sometimes I got a splodge of red or black in the middle. It was all over the place. So I was in despair. In the end I rang Michael Giles and told him I couldn't paint this base colour in, and he said never mind, he'd have a word with a firm of decorators. A few days later they sent down this little elderly man, a cockney with a fag in the corner of his mouth, permanently. And he said, 'What's the trouble mate?' I said, 'Well, this colour has got to go over these twenty-five canvases, and you're talking about something like 600 square feet [55.7sqm], by the time you've spread it all around. And I can't do it.' He said, 'Oh, I'll sort you out.' And he got a couple of buckets and said, 'What have you got here?' I'd got what seemed like several gallons of acrylic base, and a lot of tube colours. 'Oh, I'll knock it up for you,' he said, 'no trouble.' And with a wooden stick he mixed up the colour. He'd say, 'It's a bit too cool, it wants warming up a bit. Have you got any raw sienna?' So I'd give him a bit of raw sienna. He seemed terribly casual. He was chatting to me all the time and didn't seem to be concentrating one little bit. It turned out he'd just come from Washington, where he'd been doing a scheme of decoration for the interior of a library, a huge building, which meant stretching canvas over the interior of a dome and painting it all. He'd been all over the world doing this! 'Ah, that should see you through mate, that'll do you. Yea, you won't find any colour changes in that.' So I transferred it from the buckets onto the canvas with a roller, and he was as good as his word: 600 square feet [55.7sqm] and not a change at all. Beautiful.

Then I had to transfer the designs from paper. I had to do it in this room, leaning one canvas against the other, sliding them along to paint them, and bit by bit I managed to get it all done. And then towards the end, before the opening took place, we managed

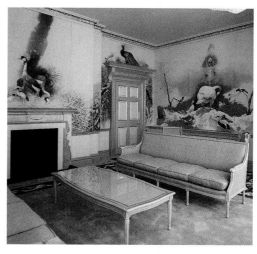

The Mural at The Holme, Regent's Park, London (1984–6)

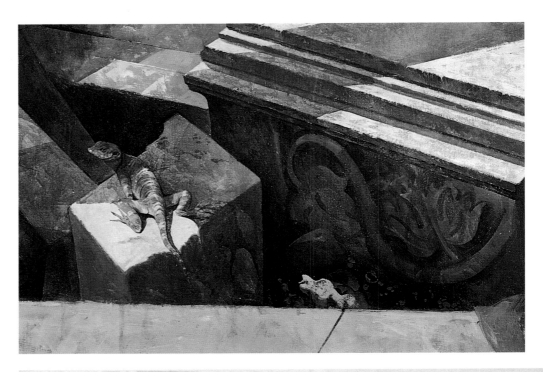

The Weybridge Mural (1982–3) (Detail)
Acrylic
private collection

Study for the Mural at The Holme
(1984–6) (On two sheets)
Pencil and watercolour,
5 ³/₄ x 6 ⁵/₈ in (14.6 x 16.8cm)
and 5 ³/₄ x 8 in (14.6 x 20.3cm)
private collection

to get the panels up in the Bow Room for me to have a look at. They weren't properly fixed but they were roughly in position. There was one nasty moment, when they had changed the drawings, but didn't tell me. A huge cornice that was built over one of the doors cut one of the birds in half. I lost it from the middle upwards. So I had to redesign some panels and paint another bird further down. But it worked out all right and in the end there was very little matching I had to do. There were occasions when something had jumped a little and I had to adjust it, but most of it went in. It was only a day's work really, running round with a brush and touching up, pushing things in. I did some final painting of some reeds on the spot, and then it was done.

Those were the main problems, and I had to invent ways of working as I went along.

The life-size bird drawings were made on brown wrapping paper, which gave a suitably coloured ground for a superb series of chalk studies. The swan illustrated overleaf is one of the few surviving examples. Although it must be understood as a working drawing, squared up as it is for transfer to canvas, it is hard to imagine a finer piece of naturalistic draughtsmanship by a contemporary artist. Like the cartoons for frescos of Renaissance masters that it emulates, the drawing reveals to the viewer three notably telling signs of quality. Firstly, it is a true working drawing, rather than a study worked up to be considered as a finished work, a sometimes dubious practice adopted by greater and lesser artists from Renaissance times onwards. Every assured line has been swiftly drawn and left in place. Secondly, the drawing of the bird's anato-

Study of a Swan (1984–6)
Chalks on brown paper, 30 ¹/₂ x 29 ¹/₂ in
(77.5 x 75cm)
private collection

my and the textures of its feathers are consummate. The shapes have been organised and shaded for best pictorial advantage, enhancing the natural grace of the swan. Thirdly, this is no still life. The drawing is not static or dead; it is full of movement and blood-warm. It is alive.

Another stage in the design process is represented by one of the elegant little studies in watercolour, made to illustrate the final scheme of conception. Characteristically, the assurance of the brushwork, on such a small scale, is invigorating. Worth has washed onto the canvas area of the drawing an approximation of the base colour that was mixed for him with disarming alacrity. Onto this he has applied watercolour and bodycolour in a flat, sometimes gestural manner that in the mural was to be softened by the increase in scale and the use of acrylic medium. But the flattened, frieze-like character of the mural has been perfectly captured, in advance.

9

AFTERMATH

On the afternoon of a perfect English summer's day, 30 August 1989, building workers were coming towards the end of the year-long task of replacing the lead on the roof of one of the National Trust's most perfect Stuart mansions. Uppark, set in an elevated position on the Sussex Downs, also contained superb Georgian interiors and furnishings which had remained virtually untouched for over some 170 years. The house was busy with visitors that Wednesday afternoon and when, at 3.38pm, the fire alarm sounded, they were calmly evacuated. Smoke was emerging from the roof, near where the workmen had been welding sheets of lead. Fire engines started to arrive within about a quarter of an hour. In all, some twenty-seven appliances were used, into the evening and throughout the night, to fight a fire that became an inferno.

The fire developed in two principal stages. The first phase destroyed the attic and roof, and broke through to the first floor, where by 5.00pm it was firmly established. By this time a huge Simon Snorkel hydraulic platform was in action, from which water could be directed precisely into the fire. The fire services were struggling to get enough water up to the top of the Downs.

Although it was evident to everyone present that this was a major fire, there were still hopes that afternoon that it might be controlled. But at around 6.30pm the second phase began, when the ceilings began to collapse and the fire spread right through the building. From the start, stewards and members of the Meade-Fetherstonhaugh family, whose home Uppark had been since 1746, had been engaged in the long and sometimes frustrating process of ferrying as many of the precious house contents as they could reach, out onto the lawns and into outbuildings.

Throughout the night firemen, rescue teams and conservators fought on to save what they could, and by the next morning the fire was at least under control. Parts of the remaining shell

Study of Uppark from the South Side, preparing to go up in the Simon Snorkel (1989)
Pen and charcoal, 10 x 14 in (25.4 x 35.6cm)
National Trust

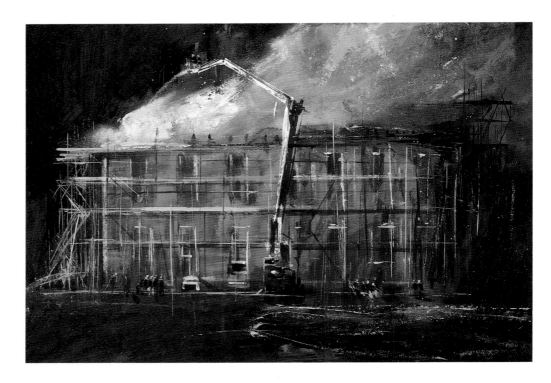

Fire at Uppark (1989)
*Watercolour and bodycolour, 10 $^1/_2$ x 14$^1/_2$ in
(26.7 x 36.8cm)
private collection*

were structurally insecure, and it would not be until the following October that National Trust officials were able to decide that enough of the interior remained to make Uppark capable of restoration. This was the greatest crisis of its kind that the Trust had ever faced. But its staff were sufficiently expert and well prepared to begin to tackle the enormous task of returning the house to its near original condition.

Through its Foundation For Art, run by Dudley Dodd, the Trust had straightaway decided that a proper visual record of events should be made. Dodd had previously commissioned Leslie Worth to make drawings of the aftermath of a previous disaster, the Great Storm of 1987, which had made a major impact on National Trust properties in southern England. Worth had recorded fallen trees in the park at Petworth, and the effectiveness of this work was probably in Dodd's mind as he telephoned Worth on the morning of 31 August 1989. Speaking just as the restoration work had finished, in the summer of 1994, Worth tells us what happened next:

> He said, 'You've heard about Uppark?', which I hadn't. And he said, 'It burned down last night. Can you go down and make some drawings?' I said I could go down in the afternoon, and he gave me the names of the people to report to, and off I went. So when I got there it was twenty-four hours after the fire had broken out. It looked pretty chaotic. In fact it reminded me very strongly of the Blitz and the air-raids on Plymouth, the same smell of water on burnt timber, which I could smell a few miles away before I got there. When I got there, there were fire teams from far and wide, running all over, and the salvage teams were moving in.
>
> So to begin with everything was in a state of flux. At first sight it looked chaotic, and then I began to realise there was a purpose in all this movement. I did very rapid drawings to begin with, just to try and tune myself into it. And then as work progressed I was able to follow it up with longer periods of staying there, and the drawings developed from the initial small sketches to something a bit more complete. And that went on, and has continued ever since.

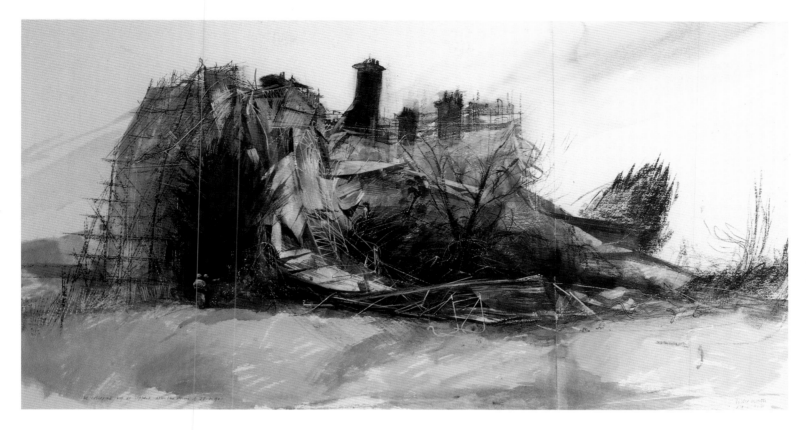

The most recent drawing I made was a very large one of the main staircase. In actual fact the drawing includes work which was never there at the same time. I first went there to make this drawing in October 1993, and the men were setting up the scaffolding in order to repair the plaster-work. The only source of light was a window above the staircase, which lit from the left, as it were. And then, in the course of reconstruction, they had to build a platform outside. And they built an extension roof beyond this window, which cut off the source of light. So they had now turned the lighting round. So I couldn't go back, and anyway I would have been in their way when they were working on the landing.

I didn't go back until about nine months later, when the scaffolding had gone and they had finally completed this marvellous, enormously intricate plaster rose in the centre of the ceiling. They did it freehand, working with a drawing of the original in the left hand, and a knife in the right, with a pile of wet plaster. It was absolutely baffling, beautifully symmetrical. It just looked as if they'd taken a plaster cast of the original and put it up. Dudley was very keen that this should be the climax of the drawing, at the top, as everything led up to this ceiling.

So, in fact the drawing straddles the nine-month period, and was never the same over that period of time, but if you accept that as a bit of licence it can have a point to it. I've got to go down to Uppark again now; they'll be going to refurbish the rooms inside, the papers will be going up, and I'll do some more drawing in there.

At the time of writing, the National Trust has acquired well over thirty of Worth's paintings and drawings of Uppark. The more poignant of these studies are those made after the hurly-burly of the first days, and as the result of his own observation. The splendid drawing of the staircase,

The Temporary Roof over Uppark Collapsed after the Storm of January 1990 (1990)
Charcoal and wash over pencil, 21¹/₂ x 42 in
(54.6 x 106.7cm)
National Trust

Aftermath (1992)
Watercolour and pen, 20¹/₄ x 21¹/₂ in
(51.4 x 54.6cm)
private collection

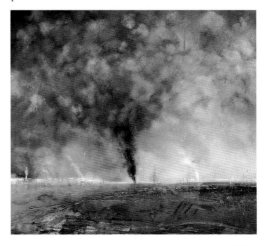

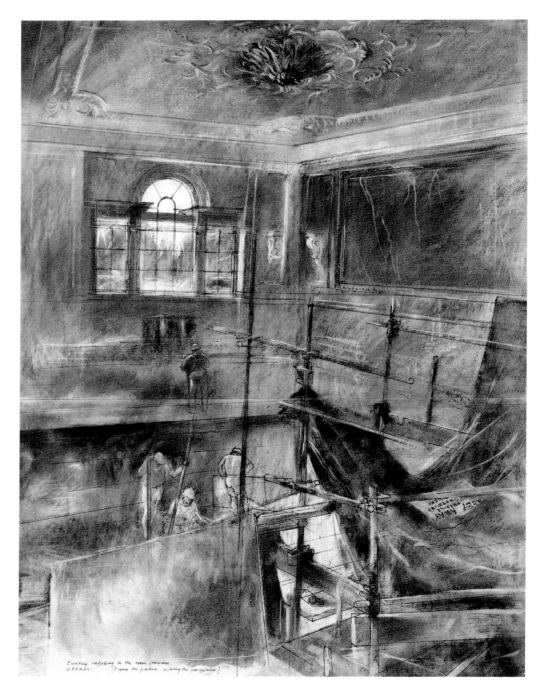

Erecting Scaffolding on the Main Staircase, Uppark (Eugene the plasterer restoring the plasterwork) (1993)
Pen, charcoal and chalk, 38 x 29 in (96.5 x 73.7 cm)
National Trust

and recollections from readers' own visits to the house, will demonstrate that although it was impossible, and indeed never intended, to create a perfect match of what had gone before, the Trust's unprecedented job of restoration was a triumph.

The studies made on Worth's first visit, and the paintings worked up from these and film and photographs taken at the height of the blaze, still provide a remarkable record of the painful series of events. The dramatically lit paintings in watercolour and bodycolour of the fire convey its ruinous power, as it cut a swathe through the building. Perhaps on the basis of the experience gained at Uppark, Worth was later to record a far more widely broadcast catastrophe from tele-

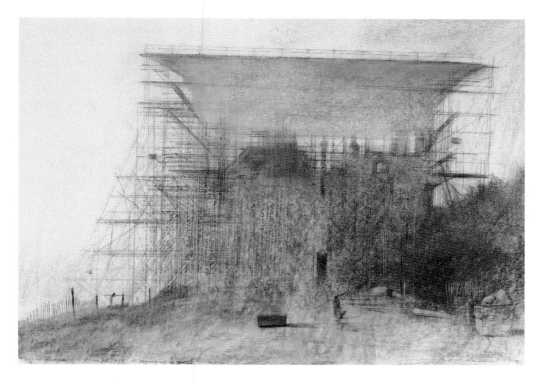

Uppark in the Fog (1989)
Charcoal, 22 x 29 in (55.9 x 73.7cm)
private collection

vision footage and newspaper photographs. In a group of watercolours he attempted to convey some of the environmental horror of the burning Kuwaiti oil wells fired by Saddam Hussein's retreating troops at the end of the 1991 Gulf War.

The chapter is concluded with a magisterial, mysterious painting of *Uppark in the Fog* (page 126–7). It can be seen that the watercolour relied entirely on an equally effective large charcoal study made on the spot in November 1989. The gaunt shell of the house is dominated by the vast, buttressed scaffolding that had urgently been erected, both to stabilise the structure and to keep out the elements. Sadly, on 25 January, the elements got the better of the new scaffold, when a second great storm struck southern England and tore down the huge temporary roof. Tragically, two workmen who had already been evacuated from the site, returned to collect their tools and were killed in the collapse.

Once again, the Trust's officials had to breathe deeply and start again. As we now know, their resolve was never in doubt. Worth recorded the aftermath of the event in a large and powerful drawing of the collapsed roof, illustrated on page 123. This superb transcription of the extraordinary tangle of twisted metal indicates the sheer horizontal force of a wind that contemptuously hurled such a massive structure aside. A complex subject is seen with the clarity, and conveyed with the lucidity, of a consummate draughtsman.

The painting of *Uppark in the Fog* reaffirms Leslie Worth's unique ability to observe and capture in watercolour the most surprising and evocative subject matter. To paint a scaffold and a skip is one thing, to paint it in the fog is quite another. The half-seen shape, rising as if organically from the Downs, brings to mind the artist's earlier comments about preferring 'life that is seen out of the corner of an eye, as it were, rather than the full frontal attack.' This lyrical, elegiac painting of the ill-fated temporary structure suggests much about the transience of things, and of people. It provides a pertinent conclusion to this survey of a selection from the *œuvre* of a profoundly meditative man, one of the outstanding British landscape painters of the late twentieth century.

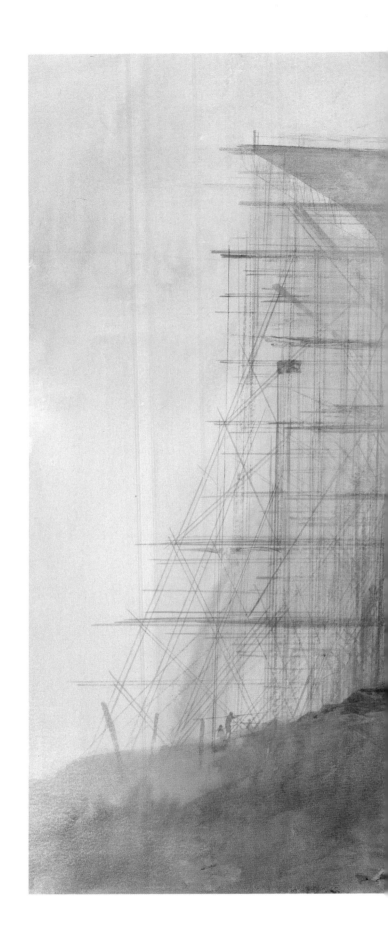

Uppark in the Fog (1989)
Watercolour and bodycolour, 22 x 29 in
(55.9 x 73.7cm)
private collection

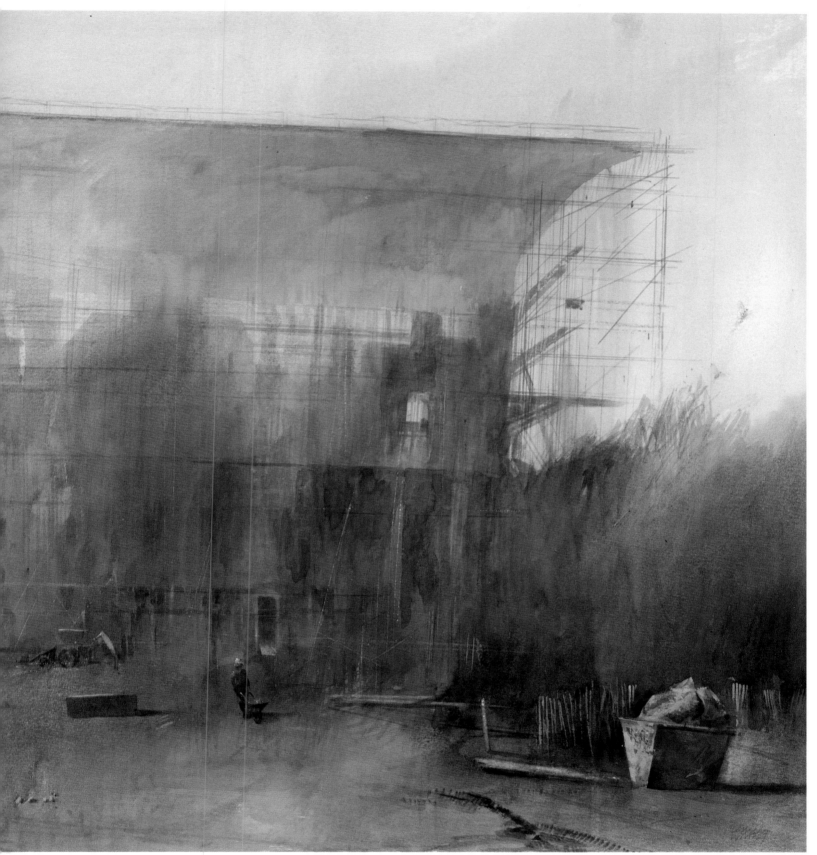

INDEX